R. J. WILCOX

DEALER IN

DRY GOODS, CLOTHING,

GROCERIES, HARDWARE, QUEENSWARE

Boots, Shoes, Hats, Caps,

Ladies' and Gents' Furnishings,

EXIE, - KY.

WE SELL THE CELEBRATED

TENNENT SHOES

THE BEST MADE

A FIT FOR EVERY FOOT
A PRICE FOR EVERY PURSE

ON THE COVER: Robert J. Wilcox began his mercantile business at Exie in Green County (front cover and above). In 1903, he purchased a lot on the east side of the Greensburg public square. He moved his store into a building on that lot, where he was joined in business by his son, Leonard Wilcox. In addition to his dry goods and clothing business, he was a stockholder in the Greensburg Loose Leaf Tobacco Company. In 1913, R.J. Wilcox invested in a movie theater with William W. Mitchell, W.B. Helm, and C.E. Blakeman. The theater operated in the former YMCA room over his store. Along with other local merchants, Wilcox lost his building and business in a 1935 fire, but he rebuilt on the same lot. After Wilcox's death in 1946, H.E. Shively purchased the building and moved his jewelry store there. (Courtesy of Terry Durham Mills.)

IMAGES
of America

GREEN COUNTY

Joseph Y. DeSpain, John R. Burch Jr.,
and Timothy Q. Hooper

ARCADIA
PUBLISHING

Published by Arcadia Publishing
Charleston, South Carolina

Printed in the United States of America

Library of Congress Control Number: 2012953776

For all general information, please contact Arcadia Publishing:
Telephone 843-853-2070
Fax 843-853-0044
E-mail sales@arcadiapublishing.com
For customer service and orders:
Toll-Free 1-888-313-2665

Visit us on the Internet at www.arcadiapublishing.com

*This book is dedicated to the memory of Samuel Wilson Moore II,
who devoted his professional life to serving Green County. This
book represents a long-held dream Sam had to produce a Green
County photographic history. To that end, he collected numerous
photographs, many of which have been used in this book. Though
Sam did not live to see the project completed, we offer this work
as a testament to his love of and devotion to Green County.*

CONTENTS

Acknowledgments

We offer our gratitude to the individuals and organizations that provided photographs for our use: Jill Henderson Best (JHB); Mae Carter Burden (MCB); Bobby Joe Burris (BJB); William Allen Calhoon (WAC); William E. and Helen M. Clark (WEC); Joe Davis (JD); Mike Deaton (MD); Ruth Lewis Derrick (RLD); Joseph Y. DeSpain (JYD); James L. Durham (JLD); Larry Ennis (LE); Evansville Museum of Arts, History and Science (EMAHS); Judy Perkins Froggett (JPF); Margaret Gaddie (MG); Mary Jean Gardner (MJG); C.E. Graham III (CEG); Green County Library (GCLIB); Martha Taylor Houk (MH); James Hugh Howell Jr. (JHH); George Mike Huddleston (GMH); Danny Jeffries (DJ); Peggy Moore Jones (PMJ); Mary Ann Kelly (MAK); Martha P. Lamkin (ML); Wanda Paxton Long (WL); Bettye MacFarland (BM); Keith Marcum (KM); Julie Megaw (JM); Marilyn Milby (MM); Nancy Coffey Mills (NCM); Terry Durham Mills (TDM); C.W. Mitchell (CWM); Peggy Thompson Mitchell (PTM); Nan Montgomery (NM); Samuel Wilson Moore II and Mary B. Moore (SWM); Jane B. Moser (JBM); Romona Murrell (RM); Mike Newton (MN); Mary Gumm Parr (MGP); W.L. Parrott Jr. (WP); William Conn Patterson (WCP); Barry Perkins (BP); Ray Perkins (RP); Millie Pickett (MP); Martha Mays Rogers (MMR); Jane Moss Shipley (JS); Kathy Shuffett (KS); Robert L. Simmons (RLS); Taylor County Historical Society (TCHS); Lanny Tucker (LT); Jolene Turner (JT); Milton Vaughn (MV); James S. Wallace (JSW); Barbara Webster (BW); Marsha Wright (MW); and Steven Wright (SW).

In addition to the individuals and institutions listed above, much credit goes to Laura Johnson and the Green County Library staff, including director Shelly Pruitt, for their willing help and gentle tolerance during the research process. Further recognition and thanks go to Dr. Robert L. Doty for his script editing; the Green County Historical Society for their support; Ruth Perkins for her fund of Green County information and constant willingness to share; Tom Mills and Walt Gorin, who provided promotional efforts to get the project off to a strong start; and to numerous other Green Countians who have helped with information. Finally, particular appreciation goes to Ann DeSpain, who supported yet another labor of love.

INTRODUCTION

Green County was founded on December 20, 1792, out of portions of Lincoln and Nelson Counties. Named after Revolutionary War hero Gen. Nathanael Greene, it was the 16th county formed in the new Commonwealth of Kentucky. Established by legislative action in 1794 on lands owned by Walter Beall, Greensburg became the county seat and the economic hub of Green County. It was located at the site of Glover's Station, one of the first forts established in Kentucky by citizens of the United States.

Prior to European settlement, the land that would one day comprise Green County was inhabited by Native Americans, who settled along the Green River and its tributaries. In the 1760s and 1770s, the new settlers frequented the area to hunt the abundant fauna—the Long Hunters were the most prominently known among those early visitors. They established a base camp (Camp Knox) named for their leader, James Knox, and built a structure called the "skinhouse," where they stored their pelts, on what is now Skinhouse Branch. Indian raids forced the hunters to abandon the camp, where they left behind approximately 2,300 deer and bear skins. When the Long Hunters returned several years later, they discovered that the furs had been destroyed; one of them reportedly carved the group's feelings on a tree, writing, "Ruination by God."

Permanent settlements, such as Pittman's Station on Pittman Creek and Glover's Station on the Green River, were established in the early 1780s by migrants from the Carolinas, Maryland, Pennsylvania, and Virginia. Many explorers and settlers arrived in the county on the Cumberland Trace, a branch of the Wilderness Road that led from present-day Taylor County through Green County and on to Fort Nashboro (now Nashville, Tennessee).

The War of 1812 brought some economic activity to Green County—several iron-ore furnaces were established in the area, helping Green County become one of Kentucky's major iron producers. When the Kentucky Legislature established 46 banks across the state, Greensburg received one of them, offering economic hope to area settlers. Unfortunately, a severe depression brought failure to the bank, but Green County still retained a bank until the Civil War.

The political strength Green County held prior to the Civil War slowly dwindled as new counties were carved out of the once-large county. By 1850, the county had basically assumed the size and shape it has today. The Civil War brought its own ravages. Guerrilla warfare was rampant, and, in 1863, Confederate forces briefly occupied Greensburg and terrorized the citizenry. Consequently, much of the population deserted their homes during the conflict.

After the Civil War ended, Green County's future looked brighter. Like other counties, Green County had joined in the fever to attract a railroad. Even before the Civil War, the county voted for two bond issues in an effort to bring three separate railroads to the county—one in 1851 for the Louisville & Nashville Railroad, one in 1852 for the Louisville & Cincinnati Railroad, and one after the war, in 1868, one for the Elizabethtown & Tennessee Railroad Company.

In 1869, the Cumberland & Ohio Railroad Company (C&O) proposed a $100,000 bond issue to build a railroad through Green County to Glasgow, Kentucky, and on to Nashville, Tennessee.

Unfortunately, financial troubles brought the effort to a halt, and Greensburg literally became the end of the line for the C&O. The failure left Green County with severe debt, and citizens were unwilling to pay the railroad tax. Since the sheriff was expected to collect taxes, no one would run for sheriff because the winner of the election would have to fulfill that duty. If one did win, he could not get a bond to cover his potential collection. Thus, the controversy impacted internal improvements all the way into the early 1900s.

Despite the debt, economic development seemed promising by 1900. New banks were established, including the Greensburg Deposit Bank in 1890, the Peoples Bank in 1902, and the Farmers Bank of Summersville in 1906. *The Greensburg Times* was established sometime in the early 1880s and reported on local activities from around 1884 to 1887. James Ward, an Englishman, established a weekly newspaper, the *Green County Record*, in 1895, which merged with the *Greensburg Herald* in 1926 and is now called the *Greensburg Record-Herald*. These developments were accompanied by the creation of various industries, the addition of tobacco warehouses, and an expansion of the county's agricultural sector, which came to dominate the county's economy.

Although the county had multiple banks and the trappings of a vibrant and growing economy in the early 1900s, economic growth stagnated. In hindsight, this was probably a consequence of the county's inability to build quality roads in the late 1800s due to its indebtedness, as counties with good roads were able to attract diverse businesses. Green County road conditions were such that even the county seat did not get well-paved roads until the 1930s, when the Works Progress Administration built them while also installing the city's first water system.

In the 1950s, Green County's fortunes turned bright again as the county became a center of oil exploration and development. The region's natural wealth in gas and oil had been known since the 1800s, but it boomed in the 1950s. The county's oil supply held such promise that Ashland Oil (now Ashland Inc.) established a terminal within Green's borders. But as was the case at other times in the county's history, the prosperity was short-lived.

The county has shown resilience in overcoming past challenges. At this time, it appears poised for resurgence; its agricultural base remains strong and new small businesses are opening in Greensburg.

One
AGRICULTURE

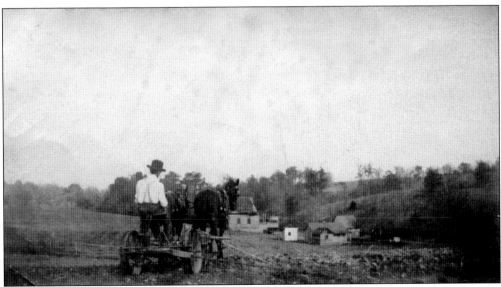

William Clayton Penick Sr. owned 187 acres of farmland about two miles from the Adair County line. Although his main cash crop was tobacco, this image shows Penick planting corn, which was used as feed for farm animals. To further supplement his income, Penick occasionally sold hogs or cattle, and his wife, Ethel Thompson Penick, sold cream and eggs. (ML.)

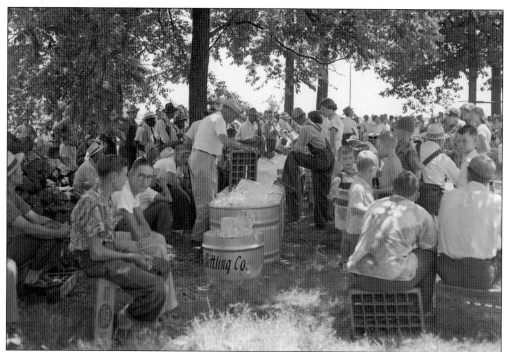

In 1947, the Greensburg Deposit Bank and the Peoples Bank began holding an annual Farmer-Banker Field Meeting on a Green County farm. The meeting included speakers on various farm issues such as soil conservation and farm management, a free picnic lunch, and a tour of the farm. The 1952 event pictured above was held on the Roy Patterson farm in the Pierce section of Green County. (TCHS.)

With four different tobacco warehouses in Greensburg at one point, farmers bringing tobacco to market filled the streets with their loaded trucks and wagons. This photograph shows a crowded Columbia Avenue as loads of tobacco are lined up to be deposited at Burley Tobacco Warehouse No. 1. With the exception of the concrete floors, all vestiges of the former warehouses are now gone. (TCHS.)

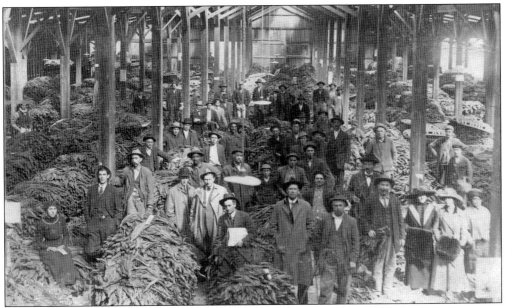

In 1798, the Kentucky Legislature established an inspection station for tobacco and hemp in Greensburg. Tobacco remained a staple agricultural product from that time forward. In 1951, for example, the Green County tobacco warehouses sold approximately 11.5 million pounds of tobacco—an amount worth over $6 million. About 50 years later, changes in production, sales, and use dropped Green County tobacco production to approximately four million pounds. The image below shows an early tobacco warehouse owned by Joseph Akin. The Flemish bond brick building was on Greensburg's South Main Street approximately where the current Five Star Convenience Store is. In addition to raising tobacco and selling it through warehouses, other businesses associated with tobacco included a prize room that prepared hogsheads of tobacco for shipping and at least two cigar factories. James Madison Howell recognized the value of outdoor advertising, as attested to by the notice scrawled on the tobacco warehouse pictured below: "Go to J.M. Howells for Drugs and Book." (Above, JYD; below, SWM.)

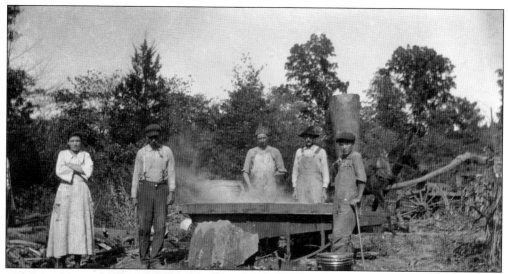

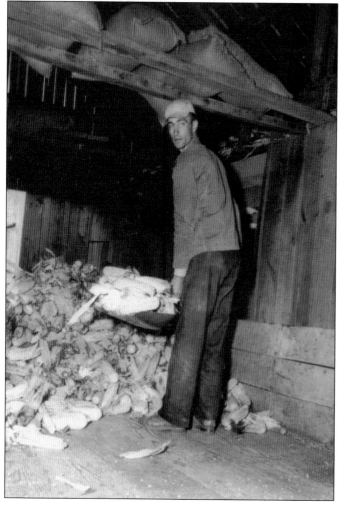

Above, a Green County family boils cane syrup for sorghum molasses. In 1899, Kentucky's first statistical report of sorghum production recorded that 21,982 acres produced 1,277,206 gallons of syrup. Sorghum molasses production dropped steadily until 1972, when an increase in sugar prices led to increased sorghum production. While sweet sorghum can net over $2,000 per acre for producers, local sorghum is primarily produced for syrup. (NCM.)

In the 1954 photograph at left, Henry Walton Mays shovels corn to be used for feed on his farm near Pleasant Valley. In 1954, 473 Green County farms reported selling 173,567 bushels of corn, up substantially from the 129 farms reporting in 1949, which sold 22,059 bushels. By 2008, Green County's corn for grain production increased to 381,000 bushels at an average of 106 bushels per acre. (MMR.)

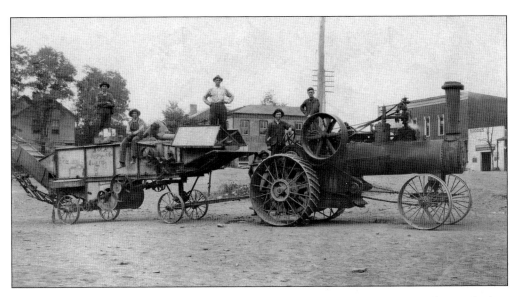

Above, G.A.K. Rogers and Company demonstrates their J.I. Case separator machine, which is pulled by a traction steam engine (also probably a Case). The separator took shocks of wheat, threshed out the grains, and blew the residual straw into a stack. In 1915, the approximate date of this photograph, a Case steel separator and steam tractor combination sold for about $880. In the 1937 image below, James Carter operates a McCormick-Deering wheat binder owned by his father-in-law, Richard Linwood Blakeman. Originally, this horse-drawn machine was used to cut and bind wheat, which was then shocked in the field and later picked up and taken by wagon to the thresher. As technology progressed, the binder and thresher were eventually merged into one machine. In 1939, Green County reported 23,278 bushels of winter wheat threshed. (Above, SWM; below, MCB.)

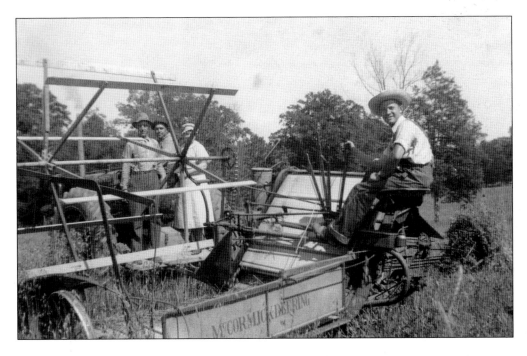

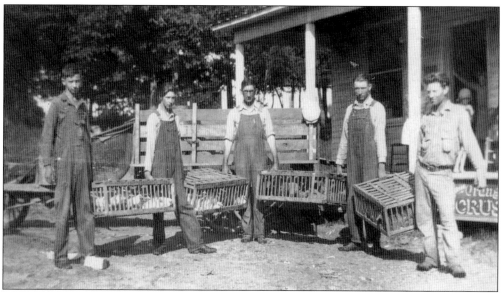

In the early 1900s, local country stores took chickens and other items as barter for store goods. Some also acted as brokers, taking chickens to town for sale at large poultry houses. The 1950s brought significant changes in how chickens were raised. In 1950, no broiler chicken house existed. But in 1956, Green County farmers raised two million broilers, making Green County Kentucky's leading broiler producer. (MGP.)

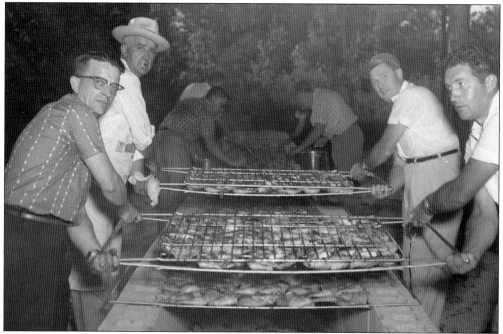

In recognition of the large broiler chicken business in Green County, the Green County Fair held the first Kentucky Broiler Festival in August 1956. The event featured barbecued chicken cooked over a 100-foot-long barbecue pit constructed of concrete blocks. Approximately 1,300 half-chickens were served. Workers turning the chicken included, clockwise from left in the foreground, Kenneth Elliot, Tate Howard, Udell Sullivan, and Cleo Fenwick. (TCHS.)

14

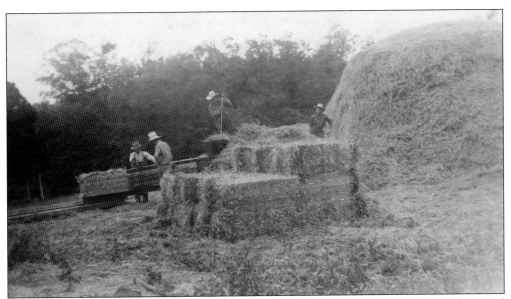

This photograph shows a hay-baling process around 1937. From left to right, Richard Linwood Blakeman and Frank McKinney thread wire and bind hay bales while "Scrap" Cook uses a pitchfork to push hay into the baler and James "Scottie" Carter forks hay onto a platform adjacent to the baling machine. Completed rectangular hay bales could weigh 100 pounds or more. (MCB.)

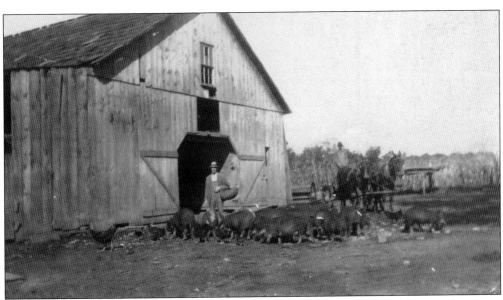

Richard Linwood Blakeman feeds hogs on his Green County farm. According to the Green County Agricultural Census taken in 1935—about the time this photograph was taken—Green County reported 7,957 swine on 1,313 farms. Just over 50 years later, in 1987, 126 farms sold 8,416 hogs and pigs for a total valued at $731,000. (MCB.)

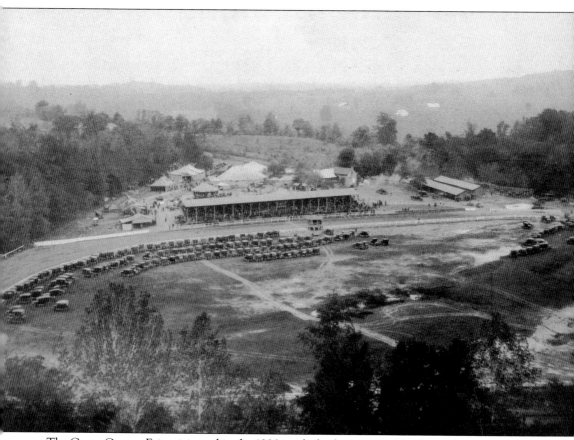

The Green County Fair originated in the 1800s with the formation of the Greensburg Agricultural and Mechanical Association. In March 1859, the association purchased land for a fairground on the Greensburg-Campbellsville road. Financial difficulties eventually led to the fairgrounds being sold in 1890. Five local businessmen formed the Green County Fair Association in 1925, purchased land on the Green River, and built a racetrack, grandstands, and other outbuildings, as seen above. In 1927, five new businessmen purchased the Green County Fair Association and its real estate. However, after a couple of fairs, the fairgrounds went unused until 1945, when the American Legion began a move to create a community park with a clubhouse and tennis, badminton, and croquet courts. The American Legion revived the annual fair with horse shows, a midway, and annual agricultural exhibits and prizes. (JHH.)

Two

ARTS, EDUCATION, AND ENTERTAINMENT

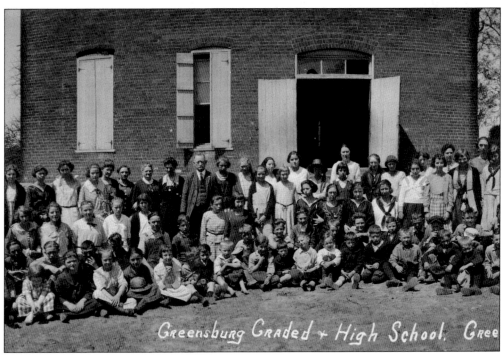

In 1798, the Kentucky Legislature established the New Athens Seminary in Greensburg. Greensburg's town trustees gave a lot to the seminary in 1816. By 1895, when the building pictured was constructed, the school was known as Greensburg Academy. The name changed again to the Greensburg Graded and High School, as indicated in this 1922 photograph, and it advertised eight grades and two years of high school. (JMS.)

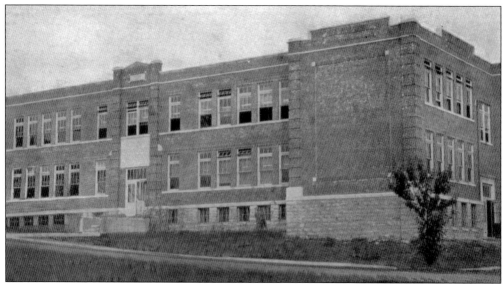

Just as Greensburg businesses suffered the ravages of fires, so did the Greensburg school system. In 1924, the school system completed a new building on Durham Street east of the city. That building burned in 1927 and was immediately replaced with the building above. However, the new building burned on Wednesday, March 1, 1950, despite the efforts of the Greensburg, Campbellsville, and Columbia fire departments. The estimated $200,000 in damages (partially visible in the image below) included a recently constructed $31,000 annex that provided space for a stage and the home economics department. School resumed the following week; classes were held in churches and other local buildings. As a result of the fire, the Greensburg Independent School District and the Green County School District merged to finance a new school (the new entity was called the Green County School Board), and in October 1951, students entered a new building on the same site. (Above, MCB; below, TCHS.)

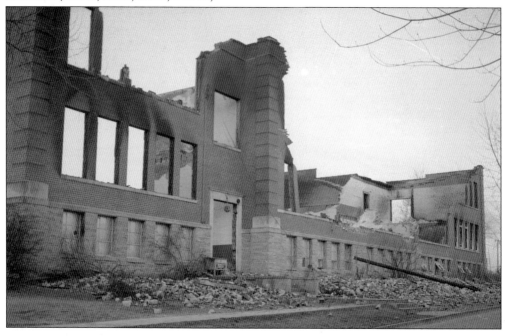

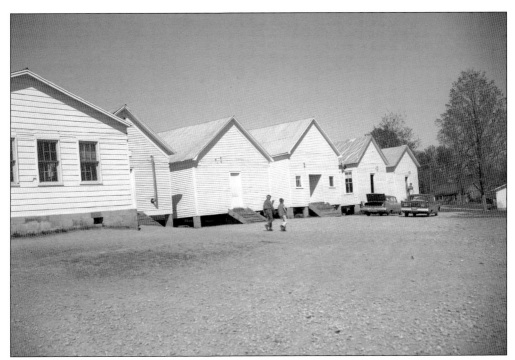

With the post–World War II baby boom and increased school enrollment resulting from the 1950s oil boom, the Green County School Board moved the one-room school buildings pictured above in from the county to provide additional classroom space. The buildings were adjacent to a World War II barracks (left) that had been dismantled by 70 Green County volunteers and moved from Louisville's Bowman Field in October 1947. (TCHS.)

In September 1917, Green County held a Patriotic Week. Planned events included public meetings throughout the county. Schools were closed on the day chosen in their district with the expectation that pupils and teachers would attend the scheduled events. In this photograph, students at the New Salem school show their patriotism with their teacher, Callie Strader Slinker (first row, far right). (MGP.)

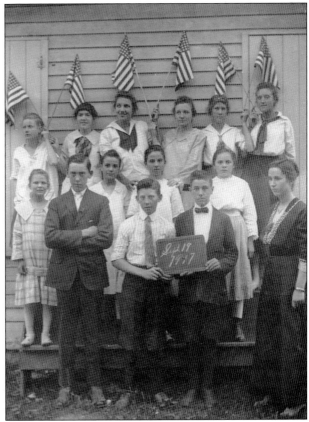

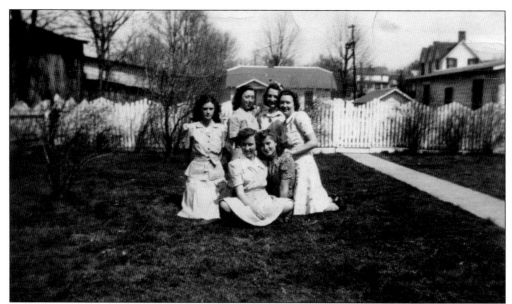

Before the school offered bus transportation for students, high school students in Greensburg rented rooms or boarded with families. This 1940 photograph shows six of the eight girls who roomed in the basement of Phares Pierce's house on Henry Street. Pierce was a grocer who lived approximately one block away from the high school when this photograph was taken. (MGP.)

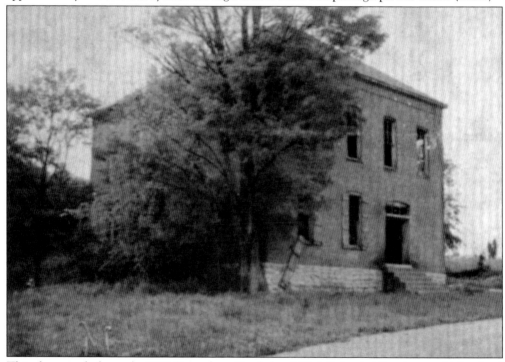

This photograph shows the 1894 Greensburg Graded and High School. After the new high school was erected on Durham Street, this building was essentially abandoned. The Christian church apparently used the structure for their congregation in 1929, when the newspaper recorded that the group was working to improve the building. It has since been torn down. (GMH.)

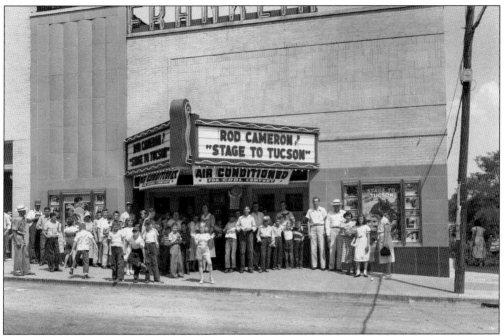

Hodges Moss started the Mossland Theatre in the Workman Building on Depot Street but moved it into a new Main Street building in 1938. The 1944 North Main Street fire destroyed several buildings, including the Mossland, and caused approximately $50,000 in damages. The fire started in the theater, which is the building at left in the image below, and quickly spread to the Masonic Hall and Robert Hartfield's garage (neither are visible in the photograph) and Shine Gorin's restaurant, the white frame building at right. After the Mossland burned, Andy Anderson of Hartford, Kentucky, purchased the property and planned a theater named the Mary Anderson, which was to be part of the Photoplay chain. However, Paul Sanders, owner of the Alhambra Theatre in Campbellsville, purchased Anderson's lot and began building an 800-seat theater to be named the Paula. Eventually, local businessmen bought Sanders's building and opened the Franklin Theatre (above), which closed in April 1968. (Above, TCHS; below, KM.)

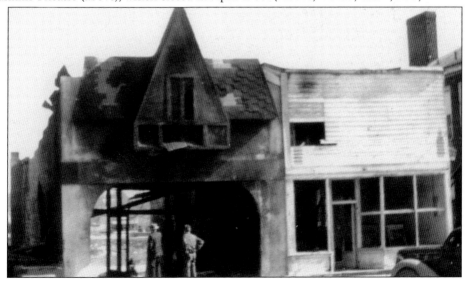

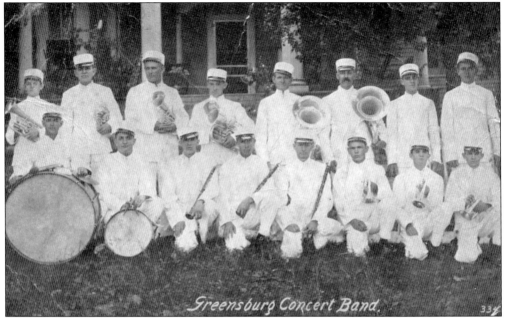

Professor Archie Brooks formed the Greensburg Concert Band, pictured above in August 1911. Soon after, local merchant Robert Braxton Buchanan measured them for uniforms, and the band debuted the new uniforms on Decoration Day 1912 in Thurlow. As their popularity increased, the band erected a 12-foot-square bandstand on the square in 1914. The city insisted that it be removed, however, and it was sold in 1916 for $2.10. (TDM.)

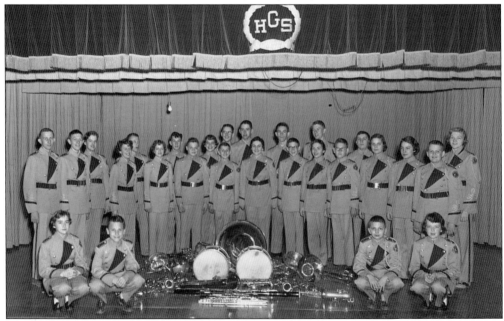

Reign H. Shipley, a recent graduate of Morehead State College, began a new Greensburg High School band program in the fall of 1952. These new medium grey, all-wool, military-style uniforms were acquired in 1954; they included a garrison cap and sleeve emblems containing a gold dragon and "Greensburg High School." (TCHS.)

What started as an unnamed quartet in 1958 turned into the Joymakers, one of Green County's longest-running gospel quartets. Although the group broke up around 1965, Buddy Lowe reorganized the group and continued. This picture of one of the earliest quartets includes, from left to right, Leland Humphrey (tenor), Bill Bradshaw (bass), Joe Tommy Hodges (second tenor), Buddy Lowe (lead), and accompanist Betty Jo Larimore Russell. (TCHS.)

One of several gospel groups formed in the 1950s and 1960s in Green County, the Gospel Tone Quartet included, from left to right, Cosby Dobson (high tenor), James "Heavy" Paxton (lead), Carl Berry (bass), Robert Leslie Sidebottom (accompanist), and Shively Coffey (second tenor). (TCHS.)

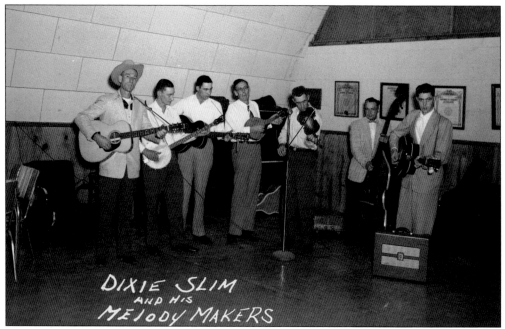

Amateur musical groups have long been a staple in Green County and remain so today. One that developed in the 1950s was Dixie Slim and his Melody Makers, who usually played local square dances. Seen here in the American Legion Clubhouse, the band included, from left to right, Garland Patterson, Boyce Workman, Doyce Workman, Tommy Bradshaw (Dixie Slim), Shively Workman, Ellis Bagby, and A.V. Ennis. (TCHS.)

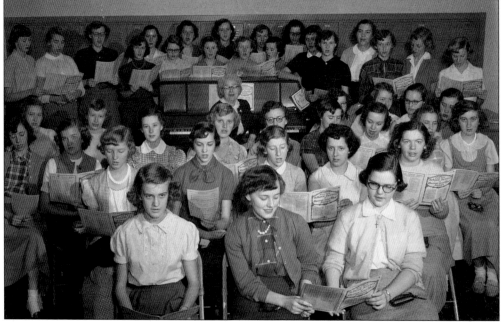

Hazel Moss Parker, pictured here at the piano, taught music in the Green County schools for almost 50 years. She also directed the Greensburg High School girls' glee club, which she is leading in this 1952 photograph. (TCHS.)

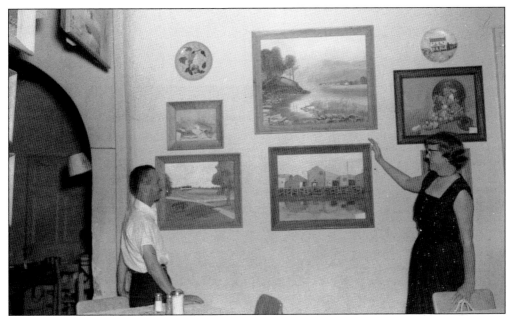

Around 1954, local artists united to form a group called the Back Porch Painters. Pansy Phillips (right) acted as the group's leader, and they met weekly. Initially, they met in the attic studio of Chester's Restaurant, owned by Chester Pickett (left). The group's annual art shows and skills brought increasing recognition to Greensburg. Here, Phillips and Pickett review some of the paintings on exhibit in 1956. (TCHS.)

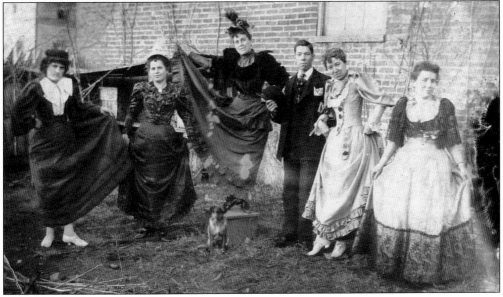

Rose (far left) and Bettie (second from left) Howell and their sister, Fannie (far right), were the daughters of William Green Howell, the former county judge and the owner of the Green River Hotel. Here, the Howell sisters join entertainers from a traveling troupe that probably stayed in the hotel. At the time this photograph was taken, probably in the early 1900s, entertainers likely performed on the Greensburg square or at the Leachman Opera House on the Summersville road. (JHH.)

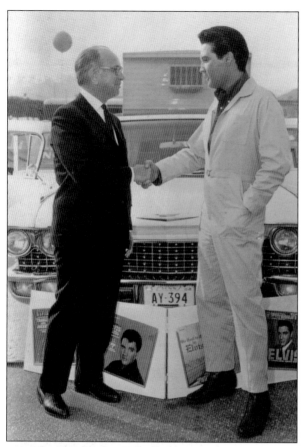

Green County native Gaylord Tucker began a successful musical career playing at Greensburg's Mossland Theatre, where his band took first prize in a 1937 competition. As his career developed, he joined Eddy Arnold at the Grand Ole Opry in 1943, managed Ernest Tubb, Justin Tubb, Bobby Helms, and the Wilburn Brothers, eventually working for Elvis Presley and Presley's manager, Col. Tom Parker. Tucker (left) is shown here with Presley in 1964. (JD.)

Many local clubs used talent shows to raise funds for projects. The 1954 Lions Club review shown below, titled the "Lions Roar of '54," featured a male follies line called Madame Sammy Lazonga's Ballet Troupe. The Lions Club members in this photograph include, from left to right, (first row) Coy Graham, Jodie DeSpain, Joe Jones, and Udell Sullivan; (second row) Gordon Kelly Durham, a hidden individual, Shively Mitchell, and Henry Wood Williams. (JYD.)

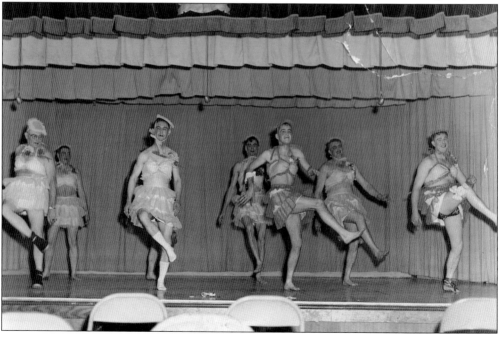

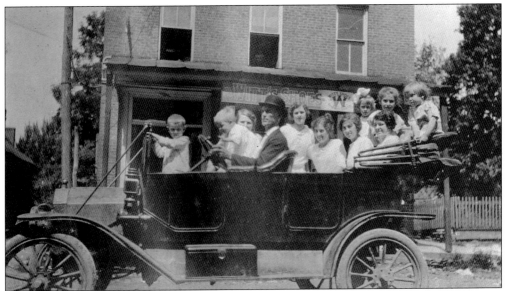

Robert D. Moss ran the Moss Hotel on Greensburg's Main Street. He began a transport service to assist customers in getting to the depot east of town, eventually purchasing a new Ford car for that purpose in 1914. While the automobile served an important business function, it provided a new form of pleasure as well. The building shown behind the automobile in the above photograph housed the Buchanan and Phillips store. (MM.)

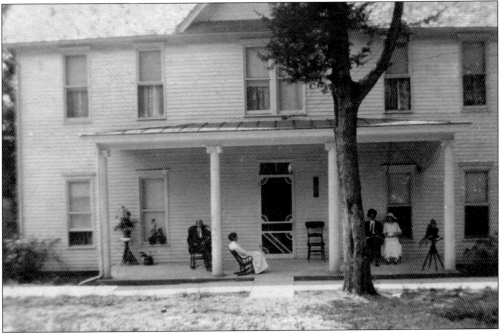

Aaron Guinn Moss purchased a planing mill in 1902. In 1909, he joined with his brothers, Henry and Mack, to build a roller, saw, and planing mill near the Greensburg depot. In 1912, they opened Greensburg's first electrical plant, which they sold to Kentucky Utilities in 1925. Aaron Moss lived in this house on West Court Street, which was between the 1933 courthouse and the present-day location of the Foster-Toler-Curry Funeral Home. (MM.)

Bettie Lewis and her dog Jack sit on the sidewalk in front of the home of her grandfather, Benjamin William Penick, on Depot Street. Originally built as a 1.5-story house, Penick purchased it in 1904, after the second story had been added in the mid-1800s. Penick sits in the middle chair with his sister Martha standing above him and his brother John in the chair at right. (TDM.)

William Hobson built this 1.5-story brick house on Depot Street around 1825. In front of the house are Hobson's son, Gen. Edward Henry Hobson, and three unidentified women, one of whom may be his wife, Kate. If Kate Hobson is in the photograph, it would date the image to a time before her death on June 18, 1872. Note the dog poking its head out of the window above and to the right of General Hobson. (SWM.)

This pre-World War I house, which was formerly located on South Main Street directly behind the Woodson Lewis building, was owned by Levi White from 1920 until 1953. White ran White's Sanitary Barber Shop in the southwest corner of the public square. Charley Lowe added the dormer windows for White in 1925. The house is now on the north side of East Hodgenville Avenue, where it was moved after it was sold in 1953. (TCHS.)

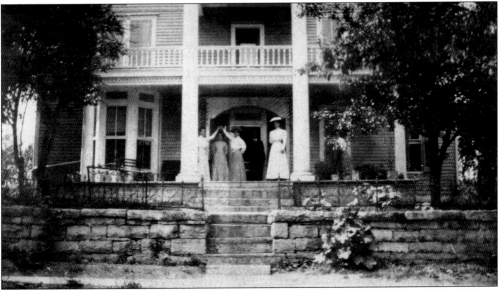

James Lapsley Wilson, a significant Greensburg businessman, owned this house. Wilson helped organize the Greensburg Deposit Bank and served as its director and president. He was also an editor of the *Greensburg Times*, which began in the late 1800s, as well as the superintendent of Green County Schools and the owner of a drugstore. The house was demolished in 1962 and replaced by the present-day Greensburg post office. (ML.)

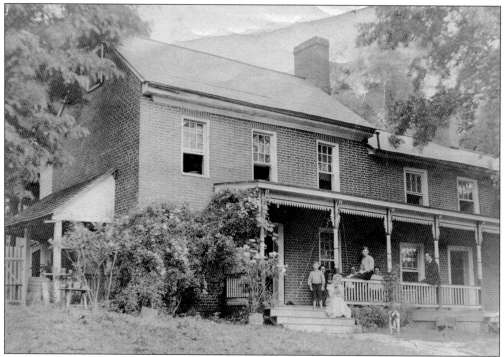

Local lore says that this house was once occupied by Greensburg Academy, an early local school where Mentor Graham taught. Constructed in three sections, the building has undergone extensive restoration and is currently a private residence. The oldest section, at left, may have been built as early as 1815. (JYD.)

Before it was destroyed, the Brummal Penick home was probably also the home of Rev. John Howe. Reverend Howe taught at one of the first classical schools in Greensburg. He also served the Siloam Church (later Greensburg Presbyterian) for about 35 years before moving to Missouri in 1845, where he died. The house was demolished to make room for the present-day Green County High School football field and vocational school. (SWM.)

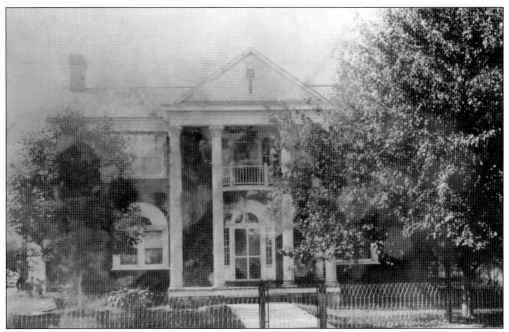

Elijah Creel built this house around 1820. Creel and other family members had extensive mercantile interests in Green and its adjoining counties. Creel reportedly built a racetrack along the Green River behind the house. (SWM.)

Jefferson Henry Vaughn, a Greensburg attorney, owned this house on what is now Henry Street. With his brother, Ralph Early Vaughn, he was also a partner in the Vaughn Brothers automobile dealership, which sold Overland and Willys-Knight vehicles. The adjacent area east of this house, known as Henry Park, was used for baseball and other events. James Durham's house is now located on this site. (MV.)

In May 1795, Nathanial Owens bought 7,500 acres between Big and Little Brush Creeks and built this home, called Lashfield, with bricks kilned on-site. The house had two large rooms downstairs, four rooms upstairs, and a one-story, three-room ell connected by a brick-covered breezeway. In the 1820s and 1830s, the home was also used as a private school for the Owens children. (BW.)

Virginia native Creed Taylor Langhorne came to Green County around 1845. A brick- and stonemason, Langhorne likely constructed this adobe house, one of the few of its kind in Kentucky, around 1850. Deeds suggest that he built a brick kiln near the house, and in 1849, the Green County Court apprenticed two young boys to Langhorne to learn brick masonry and plastering. Langhorne died in nearby Campbellsville in 1886. (JYD.)

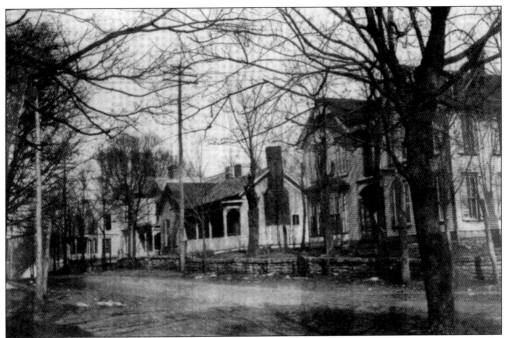

This photograph shows the east side of Greensburg's North Main Street, looking north from the intersection of Hodgenville Avenue and Main Street. The house at near right was known as the Barnett house. Next to it was the house of local merchant Arthur Miller, followed by the home of banker Lee Coakley. Robert Lee Durham's home is shown at the far end of the row of houses. Behind Durham's house is a small house in which his wife, Mary, began sewing operations that led to her becoming a manager for the American Needlecraft Company. (JYD.)

The Greensburg American Legion Rod Lowe Post No. 124 opened their new clubhouse in February 1950. The 40-by-80-foot structure included four rooms on one side of the building finished with knotty pine walls, a main room furnished with red and green leather furniture, and a kitchen equipped with a steam table, cabinets, a stove, a sink, and a refrigerator. The clubhouse contained sufficient dishes, tables, and chairs to seat and serve 100 people. (TCHS.)

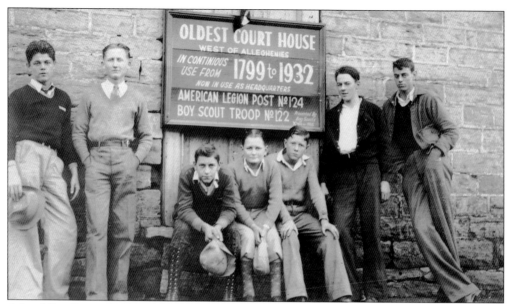

A local Boy Scout troop—No. 122, pictured above—was organized in May 1932, and in January 1933, the scoutmaster, Dr. William H. Crawford, and his troop affixed a signboard on the old courthouse that explained facts about the building. The four-by-five-foot sign reads as follows: "Oldest Court House west of Alleghenies In continuous use from 1799 to 1932 Now in use as Headquarters American Legion Post No. 124 Boy Scout troop No. 122." (JYD.)

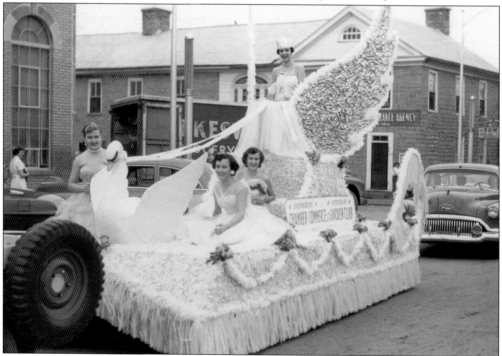

From left to right, Ada Lou Bardin Pickett, Peggy Moore Jones, Annabelle Akin Henderson, and Doris Acree Patterson ride on the Greensburg Chamber of Commerce and Garden Club float in the 1954 Green County Fair parade. (TCHS.)

Three

BUSINESS

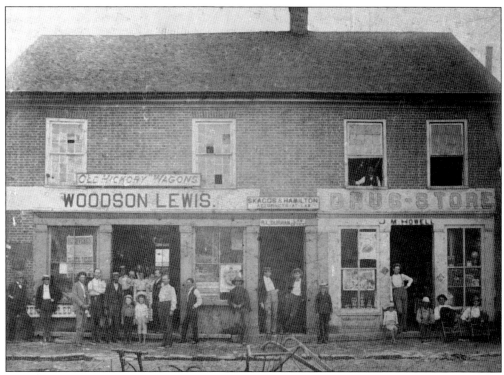

Located on a corner at the south side of the Greensburg public square, this 19th-century two-story Flemish bond brick building burned in 1900. At the time of the fire, the building housed the Woodson Lewis department store, the James A. Skaggs and James L. Hamilton law office, and the James Madison Howell drugstore. Five other buildings were destroyed in the fire, which caused an estimated $18,000 of damage. (TCHS.)

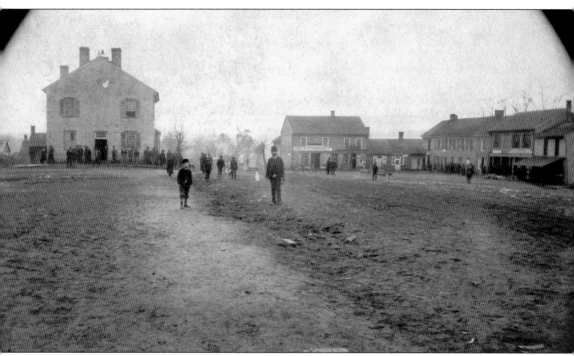

This mid-1800s photograph is the earliest known image of Greensburg. A few of these buildings remain, with the stone courthouse (at left) being the most prominent. The two-story brick building to the right of the courthouse contained the Howell and Allen dry goods store and probably the Benjamin B. Scott drugstore. It burned down in 1900. Continuing clockwise around the image, the adjacent single-story buildings housed various offices; Joseph Perry's tavern was in the two-story house slightly hidden in the corner; the five-bay, two-story building to its right served as county and circuit offices—it was demolished in 1931; the next two-story single-bay building, most recently known as Ennis' Restaurant, housed a law office. The next-to-last two-story building housed various businesses, including a saddler's shop, and the final two-story frame building held one of Greensburg's first hotels and was demolished in 1921. (JHH.)

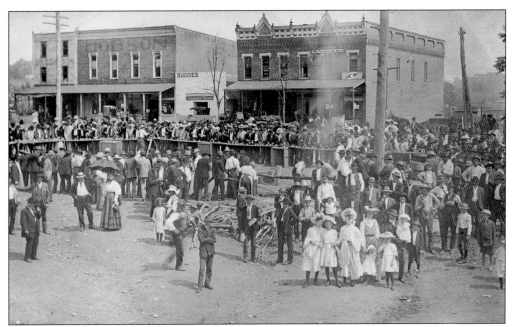

This 1912 photograph shows buildings on the east side of the public square, including, from left to right, Robert Wilcox and Son, with the YMCA on the second floor; John A. Hobson's building, which housed his store on the first floor and Hobson Hall on the second; a business that sold Tennessee wagons; and the two-story Greensburg Deposit Bank and The Peoples Cash Store, owned by William Mitchell. (BW.)

This is probably an image of a 1939 Greensburg square celebration called the Green County Free Fair. Businesses shown on the square's east side (many of which are behind the large object in the center of the image) include, from left to right, John Durham and Son Grocery; Sheldon Willock's Economy 5 and 10 Store, part of a chain with stores in Campbellsville and Columbia; George Olin Burress's New and Used Furniture; Pierce's Grocery, with Smith and Cowherd Insurance on the second floor; and the Greensburg Deposit Bank. (WL.)

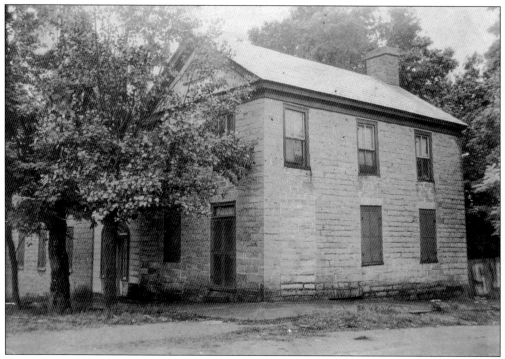

Greensburg got its first bank when the Kentucky Legislature chartered 46 independent banks across Kentucky in 1818. Local commissioners sold 1,000 shares at $100 each to capitalize the Independent Greensburg Bank at $100,000. However, a severe depression in 1819 closed many of the banks. Under authorization from the legislature, the Independent Greensburg Bank sold this building and lot in 1825. (GMH.)

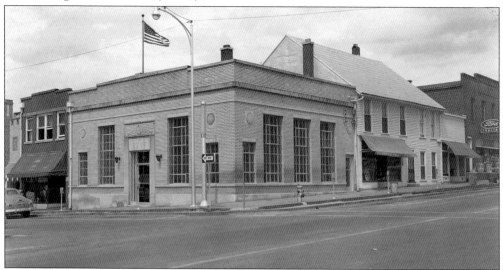

Peoples Bank completed the above building in 1930, moving from its original location, which was established in 1912 adjacent to what is now Mitchell and Edwards. Other businesses in this photograph include a barbershop to the left of the bank, Herman Hagan's Grocery, and Goff Motor Company (at far right). Local investors began Peoples Bank in 1902, and it is now known as PBI Bank. (TCHS.)

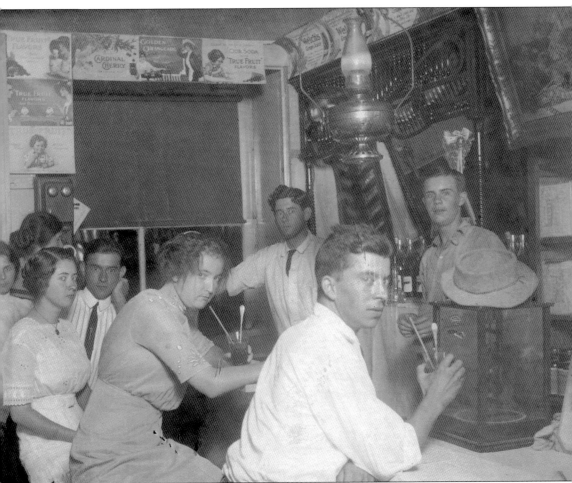

Edward Thomas Rogers (standing at left, next to the window) purchased a new soda fountain for his business in June 1912. According to the *Green County Record*, "Mr. Rogers is branching out as a caterer to those who like ice cream soda and he has arranged to deliver it to patrons residing anywhere in town." Rogers and his assistant, Houston Lowe (standing at right), provided a variety of flavors as evidenced by the advertisements seen here that promoted Cardinal Cherry, Golden Orangeade, and Welch's Grape Juice. Although Rogers' purchase was a novelty, Greensburg had been home to soda fountains since at least February 1888, when the *Greensburg Times* reported that B.E. Courts & Son had "purchased a handsome soda water apparatus, and all the machinery for making and dispensing the purest and coldest soda water, lemonade, milk shakes and all other temperance drinks." (GMH.)

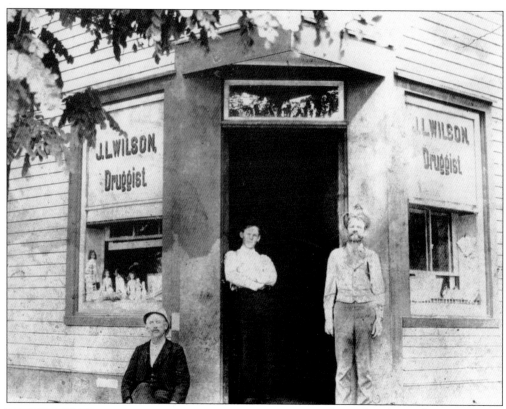

James Lapsley Wilson was the first local druggist to use the name "corner drugstore," because his store (above) was at the intersection of the Public Square and the west side of North Main Street. In 1904, Wilson moved to the west side of the square, next door to the newspaper. In 1933, Louisville architect Edgar W. Archer began designing a new corner drugstore after a fire destroyed much of the west side of the Greensburg square. Taylor Drugs moved into the new building in March 1933, but Egbert V. Taylor sold his business to Dr. Holland B. Simpson, Dr. Simpson J. Simmons, and Austin Simmons in September 1934. In June 1951, the Corner Drug Store (left) was the only Greensburg business with air conditioning. (Above, NM; left, LE.)

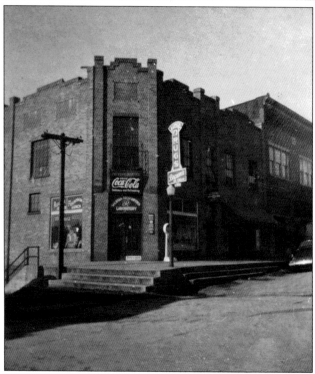

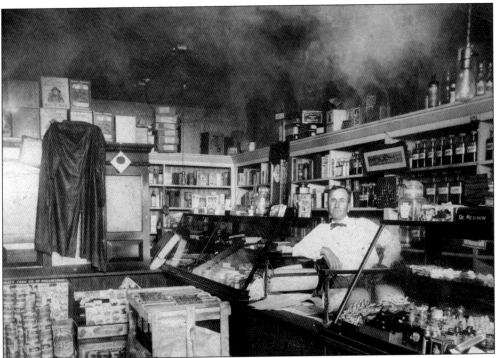

James Madison Howell poses in his drugstore on the west side of the Greensburg square in 1915. He opened the drugstore in 1900, and his son, James Hugh Howell Sr., became a pharmacist and joined James Lapsley Wilson as a partner in another Greensburg drugstore. James Hugh Howell Sr. later opened another drugstore in Campbellsville. (JHH.)

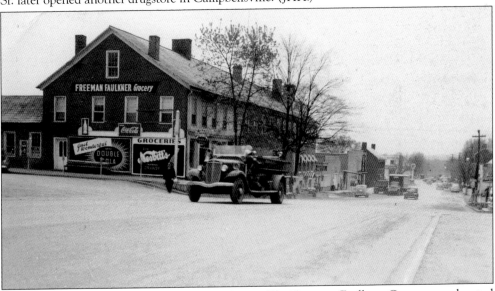

This 1951 photograph looks south on Main Street. The Freeman Faulkner Grocery was located in a section of the Green River Hotel that housed Joe Strull's Green River Cash Store from 1903 to 1912. The building two doors behind the grocery was completed in 1949 by Cecil Judd and James Skaggs and housed the Chrysler-Plymouth automobile dealership. The brick house adjacent to and beyond the dealership is known as the Dr. Thomas Webster house. (JYD.)

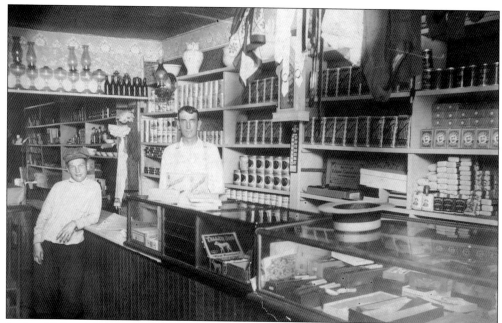

Luther Hilliard Phillips (right) purchased Benjamin F. Hatcher's grocery and lunchroom in May 1912 and later worked for Marcum's, the first chain store in Greensburg. In 1931, Phillips returned to the grocery business, becoming manager of the second Montgomery-Patrum store in Greensburg, on West Court Street, in the approximate current location of Dr. Tessa Emmon's dental office. Tom Shreve is the other man in this photograph. (JYD.)

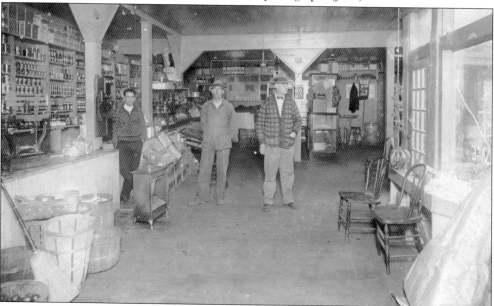

Beginning in 1923, John Durham and Sons developed into one of Kentucky's largest grocery and produce companies. The company's truck fleet delivered produce and groceries to many cities, including Pittsburgh, St. Louis, Philadelphia, and Chicago. The company also started the Kum Back Inn Drug Store. This photograph was probably taken in 1935, when the business moved to Court Street after a fire destroyed the John Durham and Sons store on the public square. (TDM.)

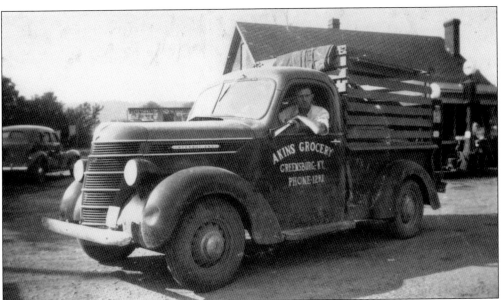

Shreve Akin purchased the Sam Anderson grocery on Court Street in August 1936 and the stock of the Mitchell Company in January 1937, making Akin's Grocery one of the largest businesses in Greensburg. It was located in the Dulworth Building, which is now part of Greensburg City Hall. In 1939, Akin added a feed line to his business and purchased an International truck to provide deliveries around the county. (JYD.)

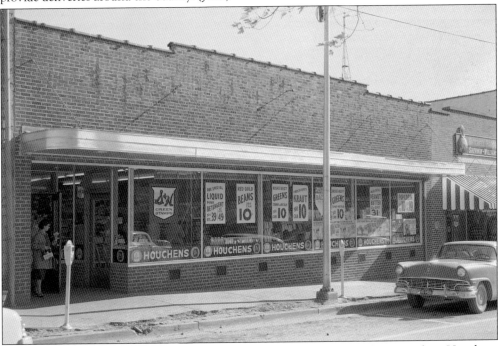

The Houchens Company added a new store to its chain when it opened the Greensburg Houchens Market on the square in November 1951. The company moved to a new store on South First Street (pictured) in 1963. This building later housed a doctor's office and a tax service and currently serves as a Jane Todd Crawford Hospital specialty clinic. (TCHS.)

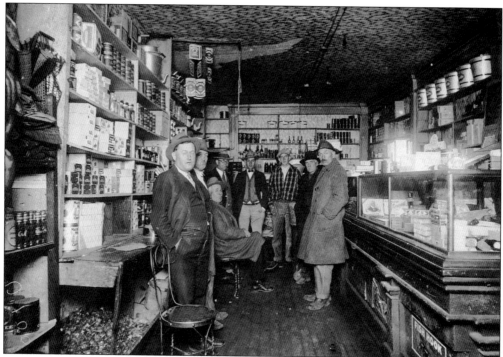

Leslie Montgomery ran a Greensburg grocery on the west side of the public square for 25 years. Pictured here inside the grocery in the 1920s are, clockwise from left, Montgomery, Joe Mitchell, James M. Howell (seated), Dr. Simpson J. Simmons, Vontress Milby, Elmer Jameson, Alonzo W. Howard, and Tom Morrison. (NM.)

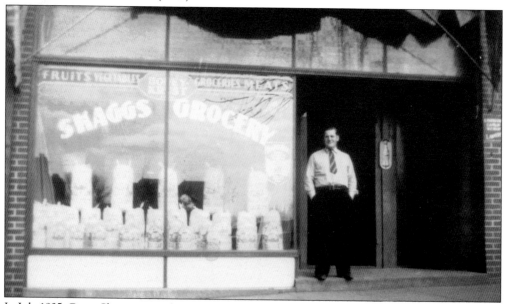

In July 1935, Cyrus Skaggs opened a grocery store on North Main Street A year later, he moved into this store next to the former Peoples Bank building. In July 1940, Skaggs disposed of his grocery stock and began selling "everything electrical," including national brands of refrigerators, radios, and washing machines. He called his new business the Green County Appliance Store. (GMH.)

The Kozy Korner first opened in a lunch car on "Vaughn's corner" (the current location of Calhoon and Cooke Insurance) and advertised steaks, sandwiches, and soft drinks. In July 1941, the restaurant moved to this location on North Main Street, where it remained until it closed. The restaurant became a well-known eatery, serving both locals and fishermen who traveled through Greensburg on the way to Lake Cumberland. (TCHS.)

This photograph shows one of Joe Daniel Carter's restaurants. Carter operated restaurants and groceries in Greensburg for more than 40 years. He also ran a bakery near the depot and a movie theater in the Masonic building. The customers pictured here are, from left to right, (first row) ? Courts, Clayton Vaughn, unidentified, Otis Moss, ? Vaughn, and ? Nunn; (second row) unidentified, unidentified, and Joe Daniel Carter. (JYD.)

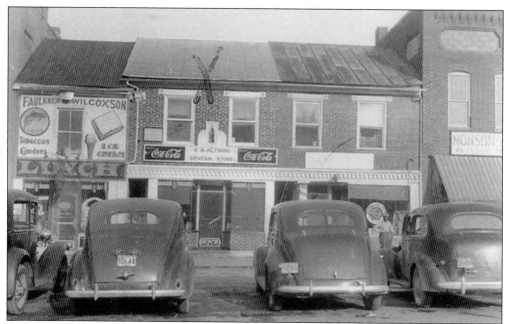

For more than 50 years, Edward Barney Altman ran a general store and harness shop in the building marked with an "X" in the above image. In 1931, Altman added an extension and opened the Friendly Café. Monson's clothing store was on the right. Faulkner and Wilcoxson's restaurant (left) later became Ennis' Restaurant, which was noted for its slawburger, a hamburger with coleslaw on it that gained some fame because of the Kentucky Headhunters' hit song, "Dumas Walker." The interior of Ennis' Restaurant is shown below. The enclosed stairs (center background) led to the apartment where Adolphus Ennis and his wife, Vera, lived. Below, Adolphus is second from left and his son, Paul, is second from right, wearing a long-sleeved shirt and leaning on the counter. (Above, WCP: below, LE.)

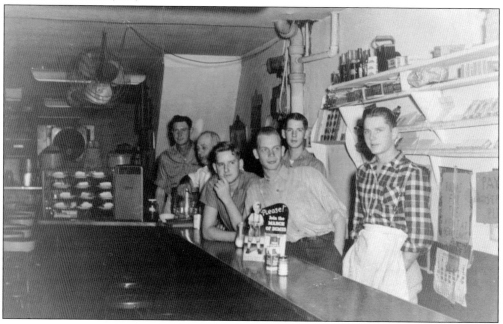

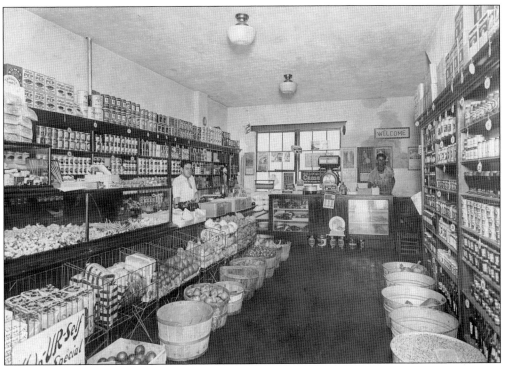

Hodges Moss began his career as a grocer in 1930 after buying the J.C. Morrison grocery. He had previously been employed by his father, Aaron Guinn Moss, in the Moss Milling Company. The above photograph shows Moss's grocery in a remodeled warehouse adjacent to the Woodson Lewis department store, where he moved after his store burned down in a 1933 fire. Moss sold the grocery to Frank Sartin and Lewis Moran in 1945. (MM.)

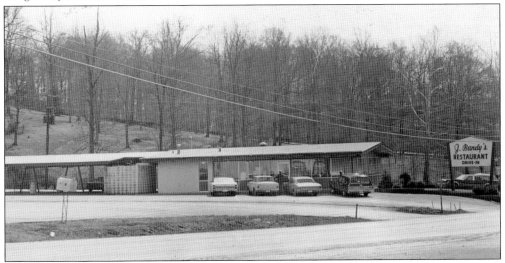

J. Bandy's Restaurant opened for business in July 1964. Enclosed on all sides by plate-glass windows, the air-conditioned dining room seated 47. The breakfast menu included bacon and eggs for 75¢. For dinner, the restaurant offered a T-bone or sirloin steak—charcoaled or grilled—for $3. Eugene Bass purchased the building in 1971 and converted it into the Green County Florist and Gift Shop. The building is now home to a church. (JYD.)

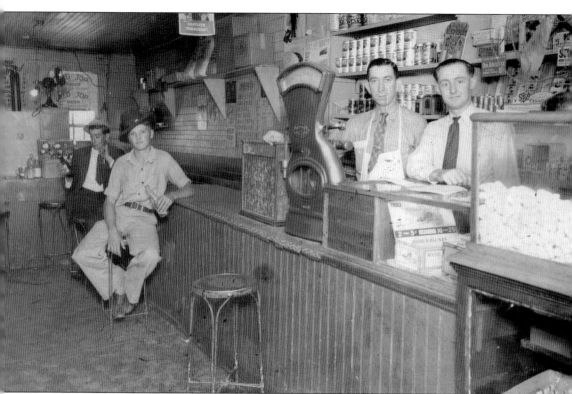

Carl Freeman Faulkner (far right) ran a number of groceries and restaurants in Greensburg. Clarence Cook, to the left of Faulkner, also worked in the restaurant. This store was probably adjacent to the Masonic Lodge. Around 1935, Faulkner purchased a lot in that location and advertised a new restaurant with 5¢ sandwiches, 10¢ soups and chili, and fried oysters. Faulkner, along with other merchants, also sold beer, as indicated by the Red Top beer advertisement in the upper left background. Greensburg beer sales returned in April 1933, a month after Prohibition ended. In a June 1937 local option, voters approved the cessation of liquor sales by a three-to-one margin. After an appeal to the State Supreme Court was dismissed, alcohol sales in the county ended for good in June 1938. (JT.)

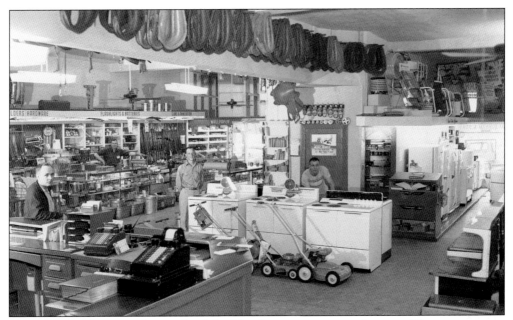

Henry Durham began working in his father's hardware store at an early age and became a partner about 1919. In 1931, he constructed this two-story building. Henry's son, James Leslie Durham, joined his father in the business, which continued until the late 1990s. This 1950s photograph includes, from left to right, James Durham, Shreve Akin, unidentified, and Holland Moore and shows the store's diverse goods and its place as a bridge between the horse-and-buggy days and increased mechanization. (TCHS.)

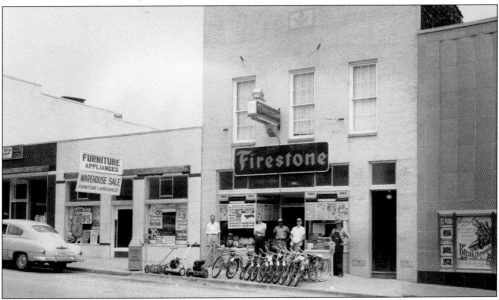

Joseph H. Mitchell's Union Oil Company leased the first floor of the Greensburg Masonic Hall for use as a Firestone store beginning in March 1946. The Greensburg store was one of seven in Mitchell's chain of stores. The company later expanded into the adjacent building, which was previously occupied by the Frozen Food Locker. In 1972, the Firestone store moved to the Durham building on Court Street, which now houses the Green County Library. (TCHS.)

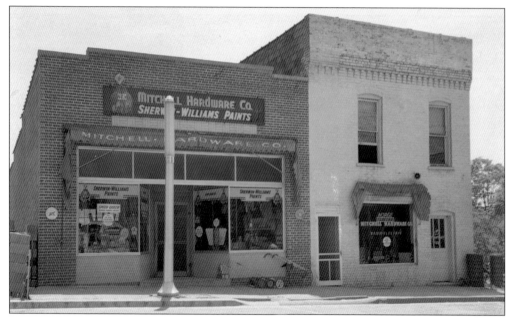

In January 1946, Mitchell Hardware moved from the basement of the Monson building at the corner of the public square and Court Street into these buildings. James Benjamin Mitchell started the company, and his sons, Clay and Paul, ran the business after their father's death. The building at right formerly housed a barbershop on the first floor with a cigar factory above it. (TCHS.)

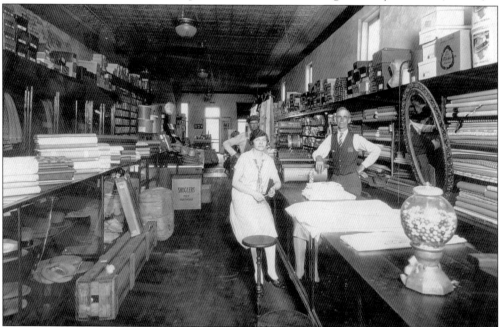

James Benjamin Mitchell first clerked at and then owned a store in Liletown. He later moved to Greensburg, where he became involved in a variety of business ventures, including this clothing store, which he purchased in partnership with James Lapsley Wilson. About 1922, Idella Edwards (seated) left teaching and purchased an interest in the store, becoming one of the few female business owners in Greensburg. (PTM.)

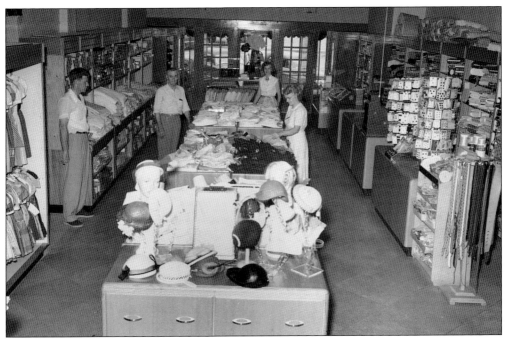

In January 1933, Ray Shuffett became a partner in the Mitchell Company with his father-in-law, James Benjamin Mitchell. Four years later, Shuffett sold his interest to Mitchell, rented space in the Durham building, and opened his own store—Shuffett's Dry Goods, pictured here in 1951. The people inside the store are, from left to right, Billy Shuffett, Ray Shuffett, Marjorie Shuffett Skaggs, and Esther Vaughn Mitchell Shuffett. (TCHS.)

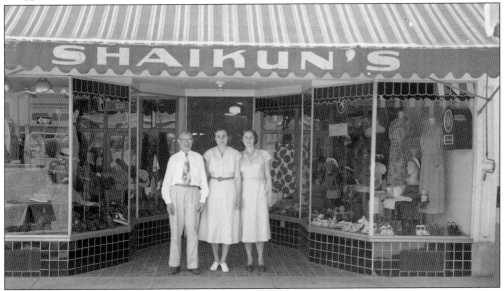

Edward Shaikun immigrated to Milwaukee, Wisconsin, from Russia at age 14 and established his first Green County store at Brushy. From there, he moved to Greensburg and operated a store for eight years. He closed the Greensburg store and moved to Louisville, but later returned to Greensburg and opened a new store on the west side of the public square. Here, Shaikun stands in front of his store with employees Kathleen Ford (center) and Ethel VanCleave. (TCHS.)

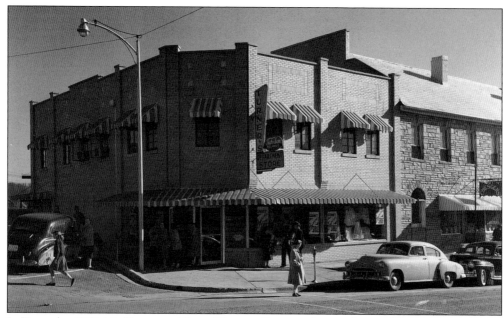

In December 1951, J.L. Turner and Son of Scottsville opened a new dry goods store in Greensburg (above and below), one of a chain of 15 stores owned by the Turners. Their first store was located in the building formerly occupied by the Frozen Food Locker on North Main Street. However, in 1953, the company moved to the Howell building, adjacent to the former Green River Hotel. Turner Stores eventually became the national chain Dollar General. William Grimsley managed the store when it was called the Greensburg Dry Goods Company. Grimsley eventually opened his own store in the Howell building and, in 1964, sold his clothing business to the Upton brothers, George and Bobby, who then opened Upton's Department Store. The photograph above also shows Chester's Restaurant, which was owned and managed by Chester Pickett. (Both, TCHS.)

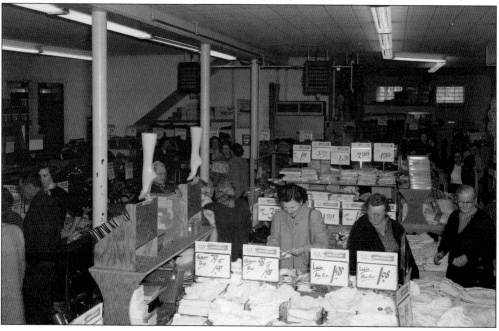

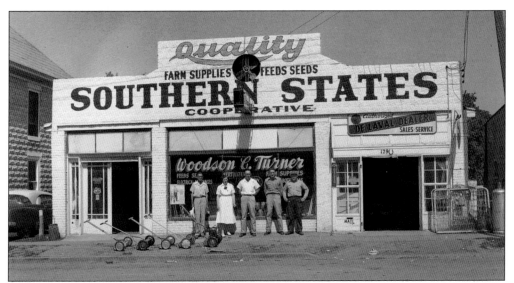

Woodson Turner began his Southern States dealership in 1945 in a building originally constructed for an automobile dealership. Edward Perkins completed the concrete structure in 1916 and, along with his son, Rollin, sold Overland automobiles and, later, Fords. Turner combined a Kaiser-Frazer automobile dealership with his Southern States farm-products dealership in the late 1940s. Forcht Bank now occupies this site. (TCHS.)

In May 1945, Everett Coleman Ennis (pictured) purchased Milton Turner's interest in the Turner and Whitlock produce business on the west side of South Main Street, where Health First Pharmacy is now located. Later owners included Willis Ford and Howard Coakley. Various poultry and produce companies had been on the site since at least 1901. The building was eventually replaced by a Standard Oil service station. (MAK.)

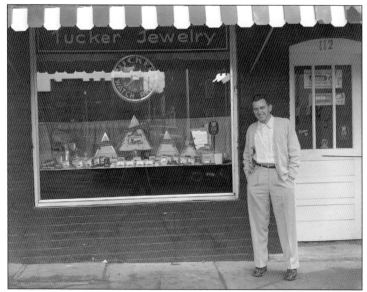

Morris Tucker Jr. opened this jewelry store in November 1956 on the southeast corner of the Greensburg Public Square. After Tucker moved his jewelry store to Campbellsville, Kentucky Utilities (KU) opened a Greensburg office in this building in April 1961 to serve local customers. Prior to the office's opening, KU customers had been served from the Campbellsville office. (TCHS.)

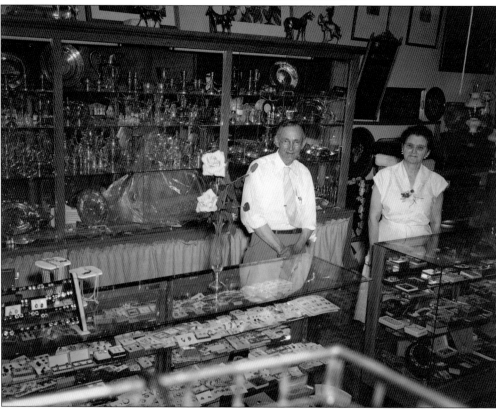

Taylor County native Hiram E. Shively opened his Greensburg jewelry and watch repair business in the Wilson Pharmacy in March 1913. Shively suffered a considerable loss in a December 1932 fire. In November 1946, with an expanded business that included silver, diamonds, crystal, and china, Shively Jewelers opened in its final location on the square's east side. Shively and his wife, Frona, are pictured here in their store. (TCHS.)

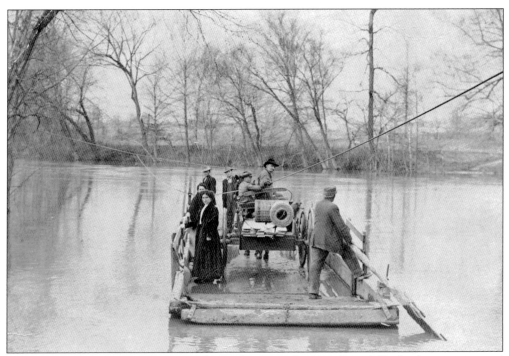

Before the 1927 bridge was constructed over the Green River at Sartin's Ford, a ferry transported people and goods across the river. There was a ferry at this location as early as 1839, when Thomas Malone, a free black man, ran the ferry. At the time of this photograph, the owner was probably Lawrence Bagby, who owned the ferry from 1919 to 1925. The man at the tiller in the rear is likely Bagby. (MCB.)

By the 1920s, buses provided Greensburg travelers with connections to Louisville and points between. Henry Lee Cantrell created the Adair Green Larue Bus Lines (AGL), providing passengers with transportation from Columbia to Elizabethtown. A 1946 effort to sell AGL to Greyhound failed, but Cantrell sold it a year later to the Tompkinsville-Greensburg bus line. Central Kentucky Bus Lines (one of their buses is pictured right) carried passengers from Columbia through Greensburg to Louisville. (JYD.)

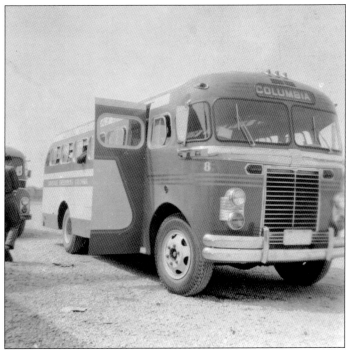

In 1851, several citizens requested that the Green County Court call an election to determine if Green County residents supported the idea of the county investing $100,000 in Louisville & Nashville Railroad (L&N) capital stock if the railroad would develop a line through Green County. The petition fell short. The Cumberland & Ohio Railroad Company (C&O) eventually built a line and completed the area's first railroad station (above), with the first passenger train pulling into Greensburg on February 25, 1880. The company failed, however, leaving the county with enormous debt. The L&N took over and, in 1913, replaced the original station with the one shown below. The *Green County Record* wrote about the new building, saying, "Lady patrons of the passenger department may await the departure of trains in comfort in an atmosphere free from the nauseating stench of tobacco chewing, pipe, cigarette and liquor." (Both, SWM.)

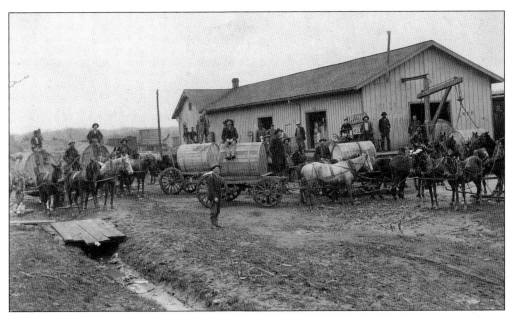

This photograph looks south at Depot Street and Greensburg's first railroad station as tobacco hogsheads are being readied for shipment prior to 1913. In the background, behind the station, is Moss Mill and an early water tank. Station agent Lucian C. Alcorn reported the following shipments of freight during the month of August 1900: "Tobacco, 171 hogsheads; Staves, 6 cars; Heading, 5 cars; Lumber, 2 cars; Wheat, 1 car." (BW.)

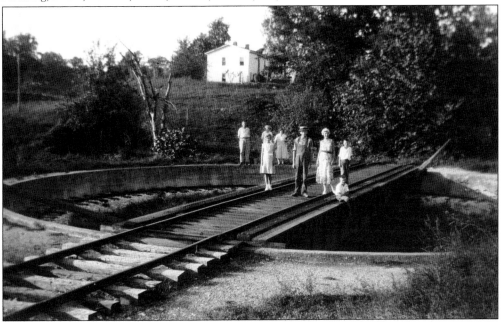

In 1913, the Louisville & Nashville Railroad (L&N) constructed this new turntable. At the same time, it pulled the old turntable farther south on the line and constructed a new depot in the old turntable's former location. Since Greensburg was the terminus for the railroad, the turntable provided a way to reorient engines for return trips to other L&N stops. The company later permanently disabled this turntable after an accidental injury. (WL.)

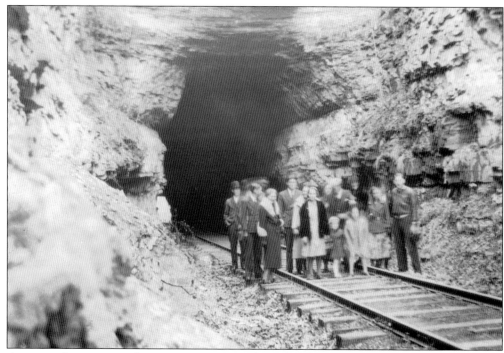

A group of visitors stands at one entrance to the railroad tunnel built by the C&O and later used by the L&N. Completed in 1880, the 450-foot tunnel ran directly under the Greensburg-Campbellsville Turnpike, which was three-fourths of a mile from the Greensburg depot. (WL.)

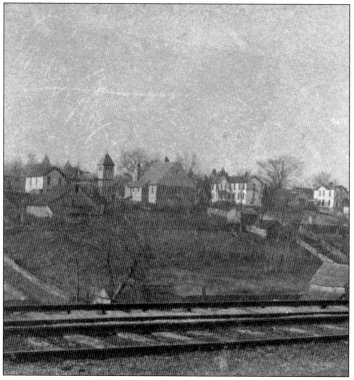

This rare photograph looks west at Greensburg from the railroad tracks. Identifiable buildings include, from left to right, the Masonic Hall; the Robert Hartfield building; the Presbyterian church; the Baptist church; the Barnett House, also known as the Barnett Hotel; and the Robert Lee Durham house (at far right). (WAC.)

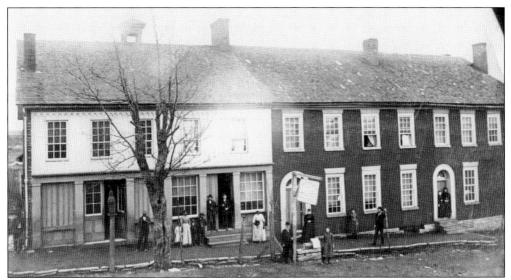

Although this building, most widely known as the Green River Hotel, appears to be a single structure, it is actually three separate entities. The middle section was probably built before 1816 by its first owner, Joseph Akin, and used, along with part of the building on the left, as a hotel and sometimes a tavern. The house on the far right, with the arched doorway, was built about 1820 by Richard A. Buckner. (JHH.)

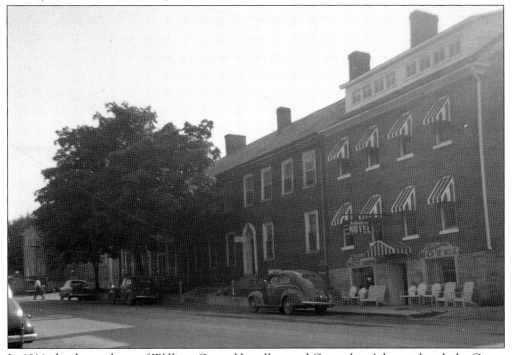

In 1914, the descendants of William Green Howell owned Greensburg's largest hotel, the Green River Hotel. Because of increased business, the family decided to expand the hotel, with additional sleeping rooms added to the south of the existing building. Alex Robinson, a local stonemason, laid the foundation for the addition. The name was changed to the Elizabeth Hotel (visible at right in the above image) in 1947. (JYD.)

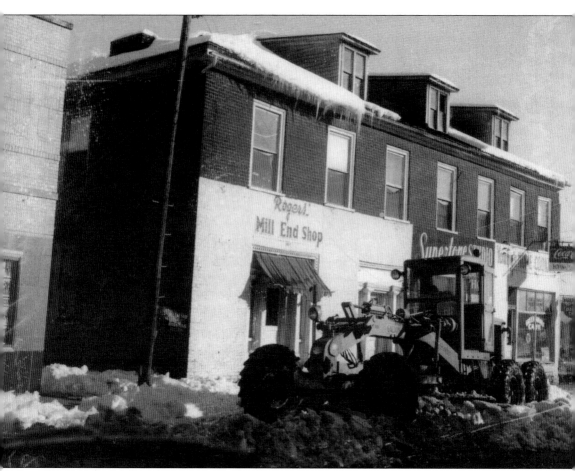

At the time of this photograph, this building was known as the Pickett Hotel, although it had also been known as the Toomey Hotel, the New Mitchell Hotel, and the Moss Hotel. William B. Allen purchased this half of the lot from the Andrew Barnett estate in 1849. Apparently a previous building had stood on the lot, as the deed only mentions the old foundation. Allen then built this structure to house the Allen Hotel and a tavern. From 1906 to 1919, the Howell family, who owned the Green River Hotel, also owned this building. At one point, the building also housed the Greensburg post office. It was eventually home to various businesses such as, from left to right, Rogers' Mill End Shop, run by Cleo Hagan Rogers; Supertone Studio; and Young's Restaurant, also known as the Greensburg Café. The building was demolished in 1961. (SWM.)

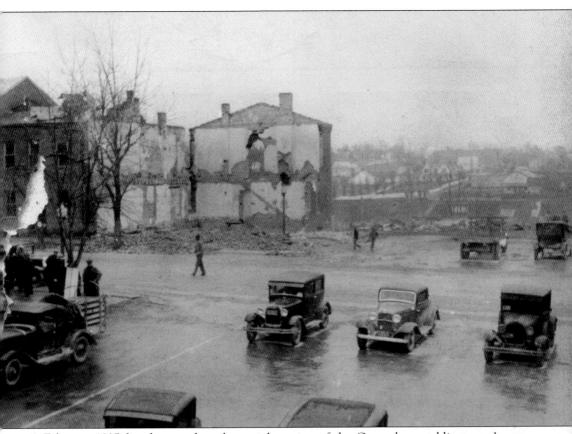

A February 1935 fire destroyed a substantial portion of the Greensburg public square's east side. The remains of the William N. Vaughn and Son store are to the left. Buildings destroyed included Robert J. Wilcox's general store, John Durham and Sons grocery store, R.H. Short's dry goods store, Henry Durham's hardware store, Phares Pierce's grocery, and the Greensburg Deposit Bank. Damages were estimated at $175,000, with only a portion of the losses covered by insurance. Elizabethtown sent a fire truck to assist in fighting the fire, while bucket brigades helped to eliminate small blazes on other buildings on the square. This fire was the third in three years, following a December 1932 fire that destroyed several buildings on the square's west side and a November 1933 fire that caused approximately $20,000 of damage to buildings on West Court Street. (CEG.)

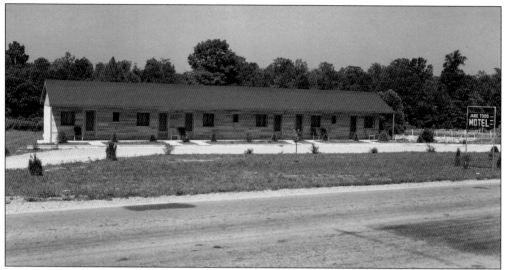

Gleason Squires and his wife, Sylvia Maye, opened the Jane Todd Crawford Motel in March 1954. The motel was composed of 12 units, each with a tile bathroom, Simmons furniture, and Beauty Rest mattresses. All units had ground entrances, with six in the front and six in the rear. The motel was named for Jane Todd Crawford, a Green County pioneer woman on whom Dr. Ephraim McDowell performed the first ovariotomy in 1809. (TCHS.)

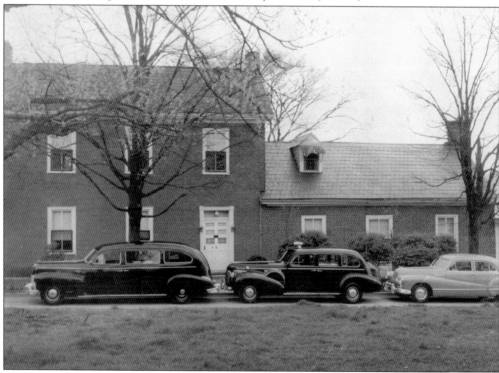

After the 1933 fire on the public square destroyed the Dulworth and Cowherd hardware store and funeral business, James Colby Cowherd renovated his South Main Street home (above) into a funeral home. Walter Lee Parrott purchased half the business in 1947, creating the Cowherd-Parrott Funeral Home. (WP.)

In April 1947, Elwood McKinney and Gleason Keltner opened the McKinney-Keltner Funeral Home on West Court Street. Keltner, John C. Bennett, and Louise Foster bought McKinney's interest and continued the business under the name Keltner-Bennett Funeral Home until McKinney bought it back and renamed it McKinney Funeral Home. This house was torn down in 2008 to make room for the parking lot of the new Green County Judicial Center. (TCHS.)

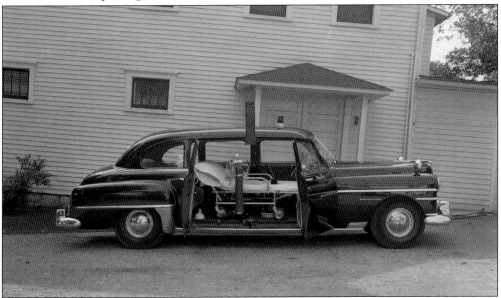

In 1947, the McKinney-Keltner Funeral Home advertised the most up-to-date rolling stock—a 1947 Cadillac hearse, two family cars, and a seven-passenger DeSoto ambulance sedan, which was designed for both safety and riding comfort. The advertisement further assured the public that the ambulance would be used for the sole purpose of transporting patients to and from the hospital. (TCHS.)

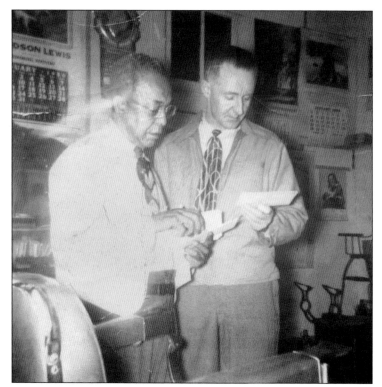

Levi White (left) began barbering in Greensburg around 1905. In 1926, he joined with Owen Henry to open White's Sanitary Barber Shop next door to what is now Long Hunter's Restaurant. Hinky Barnett and Bobby Gaddie also worked with White. Local businessman Freeman Faulkner (right) is pictured here with White in 1950, about three years before White retired. (JT.)

A Russell County native who came to Greensburg in 1919, Dr. Simpson J. Simmons practiced medicine in Green and Adair Counties for 47 years. He made significant contributions to civic and business affairs in Greensburg, serving on the city council as well as being part-owner of a Chevrolet dealership and Simmons Drug Store. He was also one of the businessmen who purchased the land that became the Green County Fairgrounds. (RLS.)

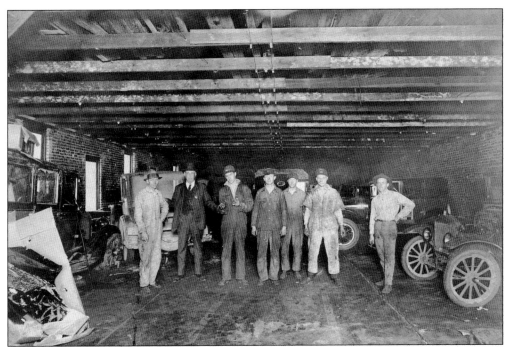

Rollin Clark (fourth from left) started working with automobiles in 1919 when the Ford Motor Company employed him as a mechanic. In 1924, he opened his first garage in Greensburg and eventually become a Whippet and Willys-Overland dealer in 1929 and a Plymouth, Chrysler, and Dodge dealer in 1931. In 1937, he joined in partnership with Floyd Patterson to purchase a Chevrolet dealership. (WEC.)

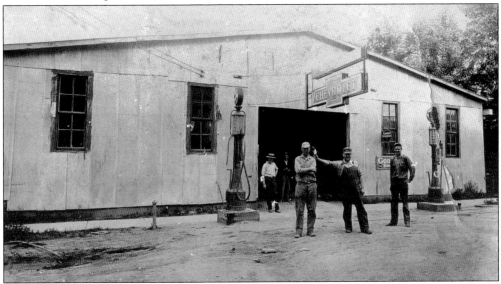

The Woodson Lewis store began selling Chevrolet automobiles in 1916. In 1926, the dealership moved to the Biggs-Mitchell Company, pictured here on the present-day site of the Green County Library, and operated there until January 1927, when William Chester Whitlock, Dr. Simpson J. Simmons, James Benjamin Mitchell, and C. Robert Buchanan purchased the business, renamed it The Chess Motor Company, and moved it to Main Street. (PTM.)

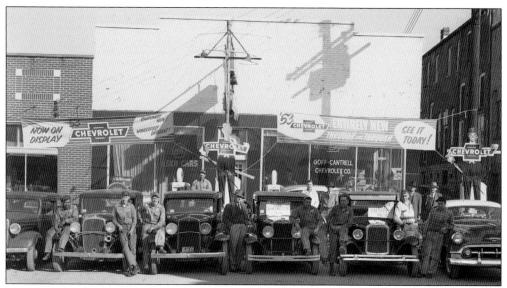

Using General Motors plans, Frank Cantrell completed a garage and showroom in 1945 for local Chevrolet dealers Floyd Patterson and Beckham Goff. Cantrell purchased Patterson's interest, creating Goff-Cantrell Chevrolet (pictured). In 1956, William Theiss purchased Goff-Cantrell and renamed it Theiss Chevrolet. Upon his death in 1970, Theiss's wife, Jeanne, sold the dealership to Bruce Milby, who moved the business to a new location and then closed it in 1982. This building now houses Snappy Tomato Pizza. (TCHS.)

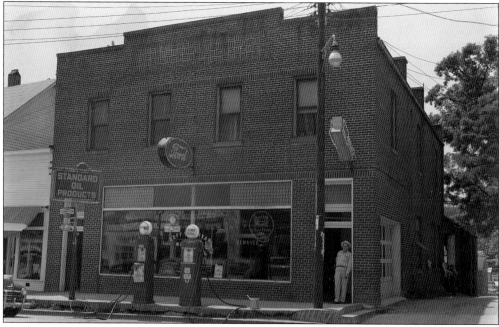

Virgil Price and Ray Goff moved their Ford dealership into a former Chevrolet dealership in 1945. Price-Goff Motors became Goff-Sullivan when Udell Sullivan bought Price's interest in 1946. Goff then bought Sullivan's interest in 1958 and created Goff Motor Company. Here, Ray Goff stands in the doorway of his business. When this building was completed in 1929, the *Greensburg Record-Herald* occupied a second-floor office. (TCHS.)

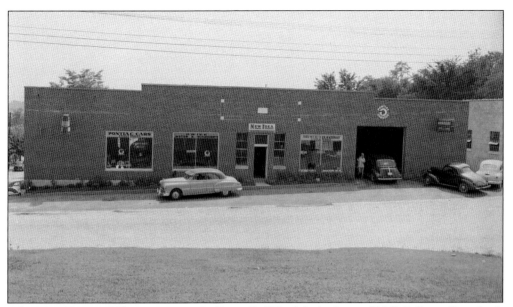

After Virgil Price sold his interest in the Price-Goff Ford dealership to Udell Sullivan, Price built this structure in 1946 for a Willys-Overland Jeep distributorship. In 1948, he became the local agent for Pontiac automobiles and John Deere implements. In the late 1800s, the Greensburg Colored Methodist Church was on this lot, followed by the Leachman Opera House, which was the first Greensburg venue to show movies. (TCHS.)

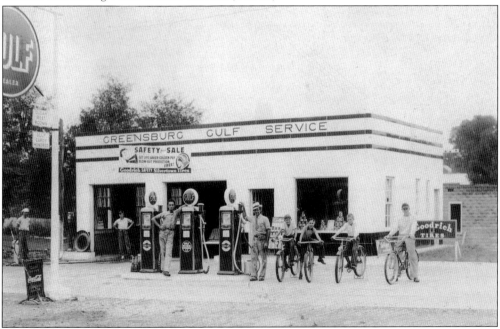

Wood Coppock of Campbellsville, the district manager for Gulf Oil, purchased this lot with Joe Anderson in 1937 for a filling station. The station opened in June 1937 with brothers Vernon and Avery Shuffett as proprietors. In March 1948, Avery Shuffett entered into a limited partnership with Arvin Slinker as co-owners of the station. Slinker became the sole owner in September 1950 when he purchased Avery's half-interest. This building now houses Rogers Auto Sales. (LE.)

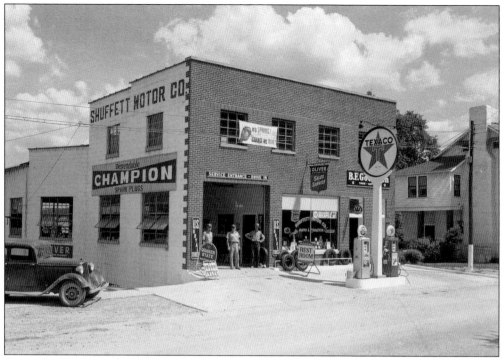

Avery Shuffett (center) got his start in the automotive business in 1936 when he created Shuffett Motor Company with his brother Vernon. In 1948, Avery Shuffett and his brother Omar completed this building for use as a garage. Two years later, Avery sold his half-interest in a Gulf station on an adjoining lot and devoted himself full-time to Shuffett Motor Company. Today, this site contains a used-car lot. (TCHS.)

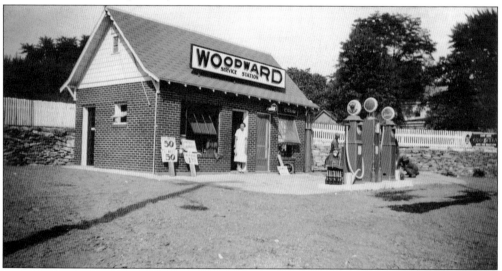

In August 1937, Harold Gorin completed the construction of this service station on the north side of the Summersville road (now West Hodgenville Avenue). Gorin was the local distributor for Stoll Oil Company of Louisville. Augustus Emerson Woodward opened the service station, where he sold White gasoline and Goodyear tires. Gorin's wife, Mathais (standing in the doorway), ran a small lunchroom in the building called the Palace Pantry. (JYD.)

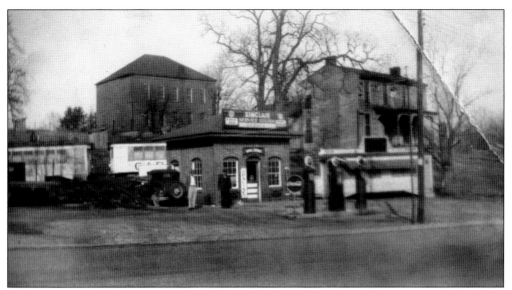

Claude Elliott Graham Sr. and John William Mauk opened this filling station in 1932, selling Gulf oil and gasoline. Claude Elliott Graham Jr. leased the station in July 1937 and sold Sinclair gasoline and oil products, as shown above. Graham Jr. sold the station in 1938 to Smith Clark, who leased the land from Allen Sanders. Taylor Wright currently operates a service station here but no longer sells gas. (CEG.)

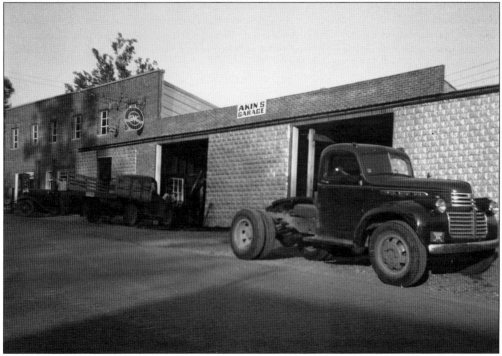

Arthur Akin ran a garage on the Campbellsville road just north of Greensburg. He was in a partnership with Walter Tucker but sold his interest to Tucker in 1937 and bought property to build his garage. After a 1946 fire caused $4,500 in damages, he rebuilt the garage and added a dealership for GMC trucks. This building was torn down before the state widened the road. (JYD.)

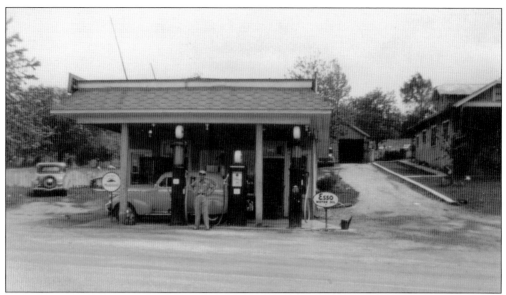

In March 1931, Fred Cowherd opened this business—a canopy-style filling station, which was favored by Standard Oil with whom he had a lease. Cowherd noted that his new station included modern conveniences such as running water, restrooms, and oil and greasing equipment. As a special attraction on opening day, every customer who purchased five gallons of gasoline received a free quart of oil. This building no longer exists. (BM.)

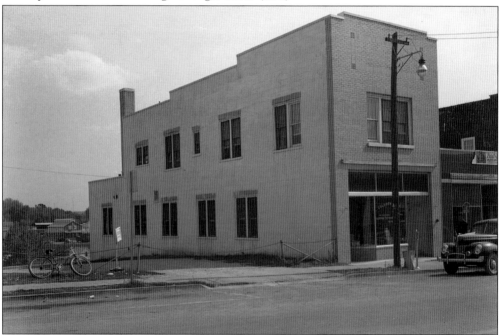

Calhoon Cleaners moved into this building when it was completed in 1945. Woodruff Calhoon and his brother, Paul, had opened their laundry business in 1932 in the Henry Durham building. In 1954, George Huddleston purchased this business from the Calhoon brothers and named it Huddleston Cleaners. This building has been replaced by the Greensburg Baptist Church's recreation center. (TCHS.)

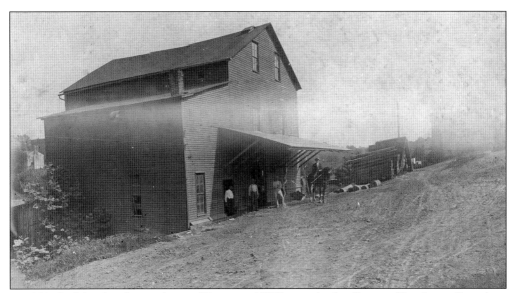

In 1909, the Moss brothers—Aaron, Henry, and William—built a flour and lumber mill on their property near the railroad depot. The flouring equipment reportedly produced 30 barrels daily. The Moss brothers also acquired Greensburg's first electrical franchise in 1912, eventually selling it to Kentucky Utilities in 1925. The company offered two lamp sizes—15-watt and 25-watt—and charged 35¢ and 50¢ per month, respectively, for them. (JMS.)

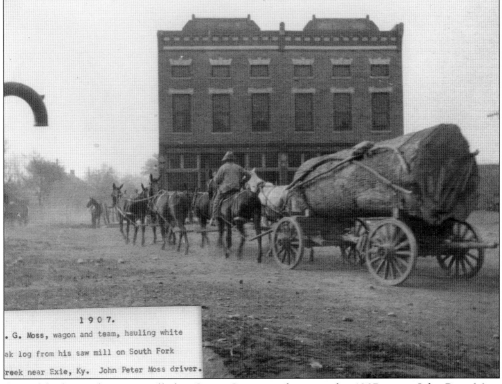

1 9 0 7.

. G. Moss, wagon and team, hauling white
ak log from his saw mill on South Fork
reek near Exie, Ky. John Peter Moss driver.

One of the largest logs ever milled in Green County is shown in this 1907 image. John Peter Moss is driving the team and the log to the Aaron Guinn Moss sawmill on Depot Street. (MM.)

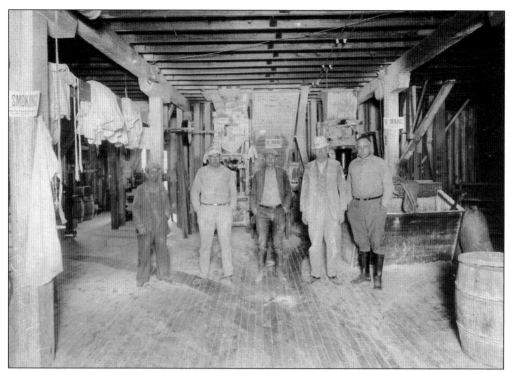

In January 1922, James B. Mitchell and Theodore J. Wilcoxson purchased mill machinery from the closed Lebanon Milling Company and moved it to a new mill site on South Columbia Avenue in Greensburg. After it was completed in September 1922, the mill (pictured below) had an estimated output of 50 barrels of flour per day, which included a product named Green River Belle. Shortly thereafter, the company added Greensburg's first ice plant, which had been shipped in by train. Standing in the mill in the photograph above are, from left to right, Shorty Montgomery, Roscoe Wilcoxson, Selby Mitchell, Theodore J. Wilcoxson, and Finis Wilson. Unfortunately, in December 1929, the mill and the ice plant burned along with the adjacent Durham and Son lumberyard. The mill suffered an estimated $45,000 loss, and Durham lost $7,000. A bucket brigade prevented the nearby Buchanan-Lyon Wholesale Company house from burning. (Both, JYD.)

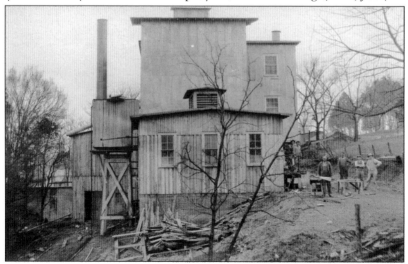

Originally built in 1925 for the Buchanan-Lyon Wholesale Company of Campbellsville, this property was purchased by William R. Myers, a former Greensburg miller, in 1935 and converted to a feed and grain mill. Financial troubles forced the mill to be sold at the courthouse door in 1940. Adolphus Rogers and Alvin Willis purchased the property and eventually sold it to the Winn brothers, who established the Winn Milling Company, which is pictured above. (TCHS.)

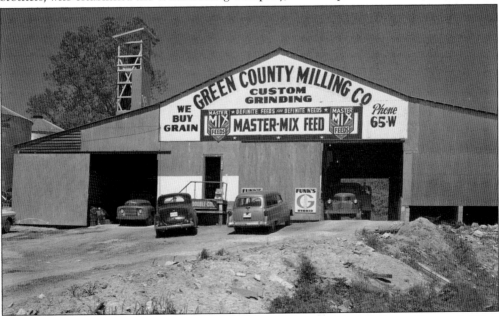

Walter Mitchell, Billy Shuffett, and Carl Thomas O'Banion opened Green County Milling Company in October 1954 near the Green County stockyards. The newly constructed building housed modern machinery that provided custom grain grinding and feed mixing. O'Banion operated the business and was assisted by Rusty Clark and Paul Gardner. Brothers Terry L., Winford, and Kenneth Goff purchased the mill in 1960. It is no longer in operation. (TCHS.)

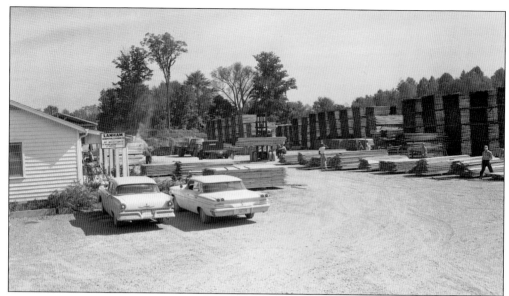

Lanham Flooring Company established a production facility in Greensburg in 1956 and also maintained a warehouse in Louisville. After Lanham closed in 1968, the Jasper Corporation of Jasper, Indiana, purchased the 35-acre lumber facility. Jasper manufactured parts for Kimball pianos and organs as well as wooden cabinets for RCA, General Electric, and others. Jasper renamed this operation Greensburg Manufacturing Company, and it produced dimension lumber for furniture and cabinet construction. (TCHS.)

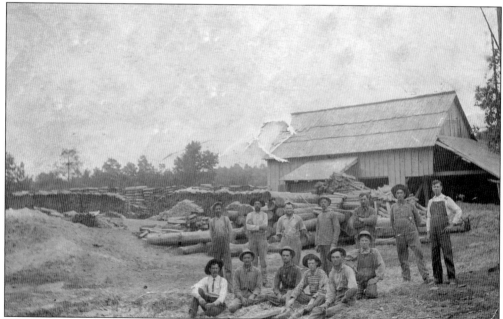

Although these loggers and their exact location in Green County are unidentified, they represent the large operation that logging became in the late 1800s. One major operation was named Bluff Boom after the Wright and Brothers Mill put a boom from a large bluff across the Green River to catch logs for their milling operation. The mill reportedly turned out 10,000 feet of lumber per year. (TDM.)

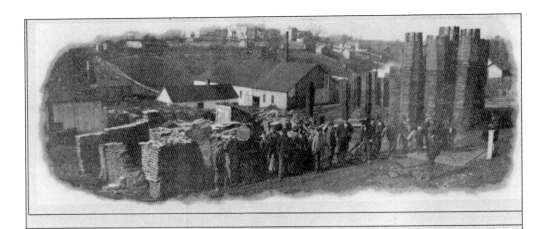

L. P. Bardin

Manufacturer of

Full Dressed Beer Staves, Bucked Whiskey Staves
Square and Circled Heading and Hickory Dowell Pins

Greensburg, Ky.

Luther Peter Bardin's stave mill sat next to the railroad, near the present-day location of the fire department. Bardin purchased white oak to produce barrel staves. In 1904, the *Green County Record* noted that the roads from Summersville were "badly worn" from hauling Bardin's staves for shipment. The editor encouraged the teamsters to haul rock or gravel on their return trips and "throw the same in the ruts." (SWM.)

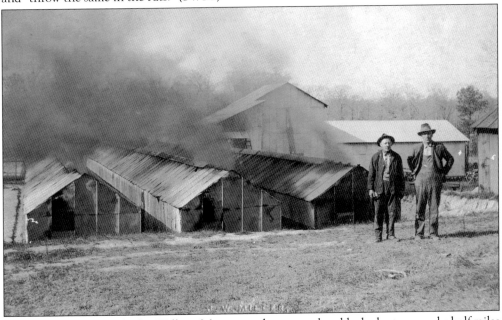

E.E. Patterson (left) and John William Moore stand near a carbon black plant one and a half miles south of Greensburg on the James Madison Howell farm. Developed in 1923, the plant used gas from nearby wells owned by Moore and Dwight Sandidge. Green County's largest carbon black plant was in Whitewood on the White farm and was fueled by the numerous successful gas wells in the area. (SWM.)

This property, known as a mill site since the late 1700s, was purchased by David Montgomery in 1849, and it came to be known as Montgomery's Mill. In this 1850 photograph, George McClellan Foster works on the pulley wheel that is driven by a water-powered turbine in the mill's forebay, which is below Foster. A cable connects the pulley wheel to the milling operation in the distance. (JYD.)

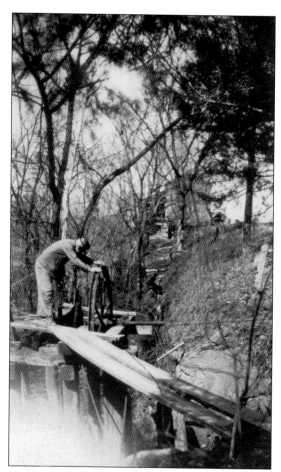

After Dr. Nimrod Arnold purchased the mill site—later known as Montgomery's Mill—at the narrows of Pitman Creek in 1820, he completed a channel through the narrow neck of land between the upstream and downstream sides of the creek and then built an upstream dam that forced water through the channel in order to drive the mill wheel. In the image below, George McClellan Foster and his granddaughter, Mattie Foster, stand on the milldam. (JYD.)

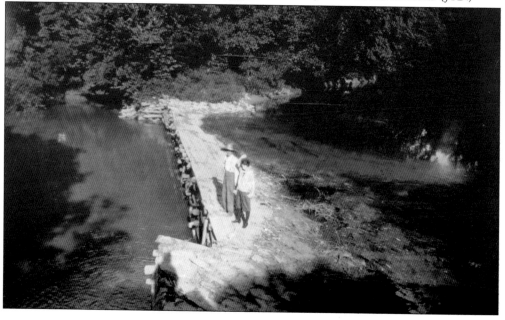

Each spring, for more than 50 years, Greensburg Bottling Company hosted Green County school students on a plant tour. In addition to the tour, students received a soft drink, often a package of potato chips, and a company pencil. Here, teacher Mary Beams (left) stands by as Gabriel Buckner Taylor, one of the original company owners, passes out pencils to members of her class in May 1960. (TCHS.)

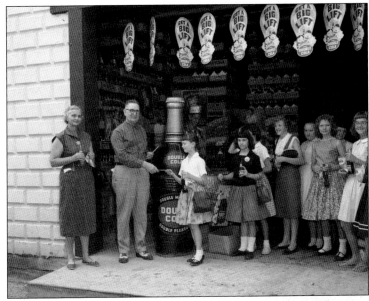

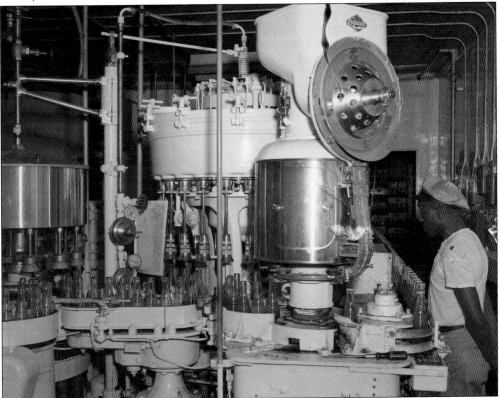

Original papers show that seven investors incorporated the Ocean Breeze Bottling Company in 1925. The company later became known as the Greensburg Bottling Company. Cocoa Crush was one of the company's first products. In 1933, the company became a franchise bottler for Double Cola, which was the company's leading product until the development of Ski. In this photograph, Gaither "Caesar" Barnett monitors the production of Nesbitt's Orange. (TCHS.)

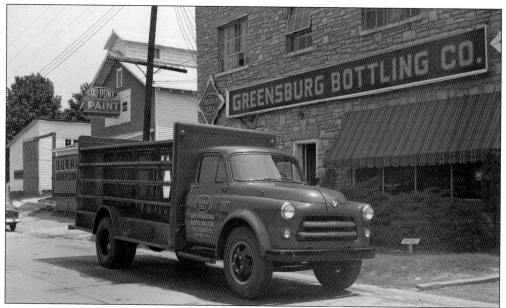

In this image, the Durham Lumber Company is visible behind the Greensburg Bottling Company's newly acquired 1952 Dodge truck. Mayes Durham and his father, Robert Lee Durham, started Durham Lumber in 1926, and Mayes continued the company after his father's death in 1947. In 1961, Mayes sold the business to Buckhorn Lumber Company of Campbellsville. That same year, George Olin Burress purchased one-half interest in Buckhorn Lumber Company and later created Greensburg Lumber Company. (TCHS.)

Distillers began operating in Green County in the late 1790s. In the 1880s, at least four legal brandy distilleries operated in the county. From the late 19th century until the early 20th century, a total of 22 licensed whiskey distillers operated in various parts of the county. After the passage of Prohibition in 1920, moonshiners flourished. This photograph shows the remains of a distillery on the Little Barren River. (JPF.)

At right, Mary Uldon Gumm Parr stands on the porch of her grandfather Joseph Wilson Gumm's store near New Salem Baptist Church in Gumsville. Joseph Gumm and his wife, Nettie Russell Gumm, purchased the store in 1918. In addition to his store responsibilities, Gumm also served as the Gumsville postmaster from January 23, 1928 to August 21, 1942. Nettie Gumm sold sewing needles and thread on one side of the store. (MGP.)

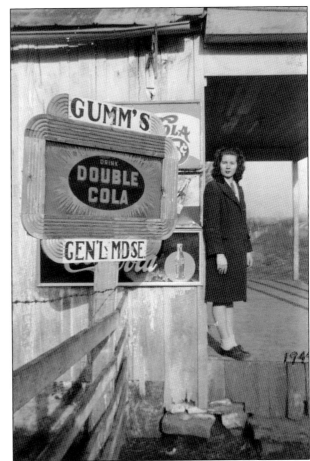

The c. 1910 photograph below shows the Thurlow store (at left), which Robert Iverson Taylor began in 1881. Taylor later sold it, and the store changed hands several times before he repurchased it. He and his son, Lindsey Caldwell Taylor, then operated under the name Taylor and Son. The Mt. Lebanon United Methodist Church (in the background at right) was destroyed by a tornado in 1964 and replaced with a brick structure. (MH.)

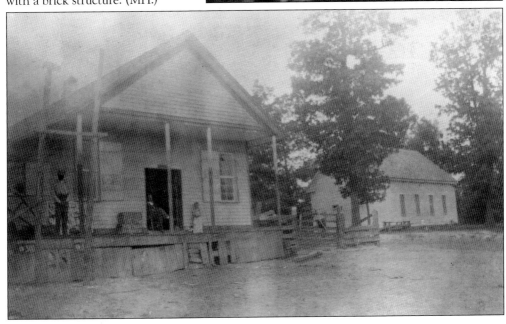

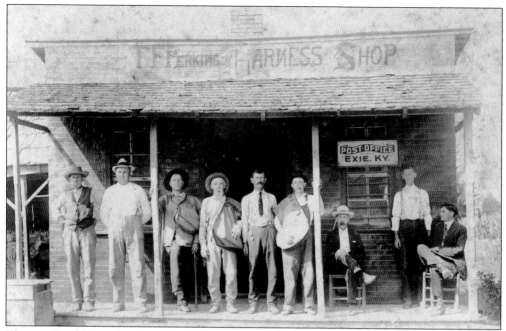

Thomas Franklin Perkins ran a store and harness shop in Exie, Kentucky. He is pictured here along with other area residents and store owners including, from left to right, Chris Jones; Leonard Wilcox, an Exie store owner for about 50 years; Ed Beard, a local mail carrier; Charlie Buckner; Perkins; Selby Mitchell; E.L. Kaie; Robert Whitlock, an Exie store owner; and Edgar Judd, a Liletown store owner. Note the letter box just below the right window. (RM.)

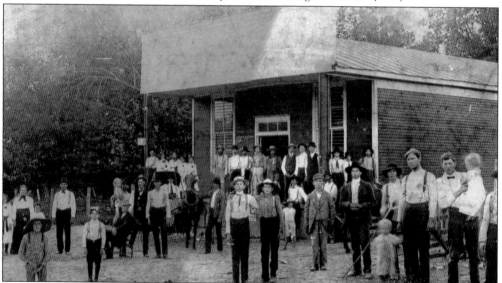

Joseph A. "Ab" Hubbard began his mercantile career in Liletown, which is pictured here during a gathering in the small town. A Metcalfe County native, Hubbard completed a degree at the University of Kentucky and taught for several years before entering business. In January 1912, he resigned as Liletown postmaster to become president of the Greensburg Loose Leaf Warehouse Company. He spent 30 years in the tobacco business in addition to being active in various other businesses and civic activities. (GMH.)

This 1904 photograph looks north from the Liletown road toward Pierce. The building on the right, which housed the Masonic Hall and the post office, burned down in 1915. Ben Thompson's store and house is in the center. Established on John Sandidge's land, Pierce was originally named Brewersburg, and in 1834, the Kentucky Legislature established a Brewersburg voting precinct for all land south of the Green River. (JSW.)

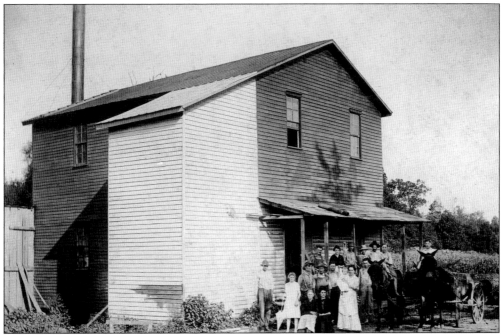

In 1897, Isham Brown Pierce acquired land in the Pierce community to build this flour mill. Pierce sold two-thirds interest in the mill to Steward Patterson in 1914 with the requirement that the land be returned to Pierce if it ceased to contain a mill. John Rayburn purchased the flour and corn mill and a saw rig from Patterson in 1919. The mill was torn down in 1964. (JSW.)

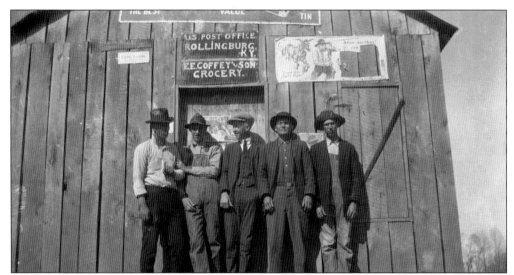

Edward E. Coffey ran this grocery store in Rollingburg, served as the Rollingburg postmaster for more than 12 years, and represented the third magisterial district on the Green County Fiscal Court for several terms. In 1930, he moved to Greensburg and opened Coffey's Grocery across from Greensburg High School. After his death in 1938, Coffey's Grocery continued to be the mid-morning or lunch place to be for Greensburg High School students. (NCM.)

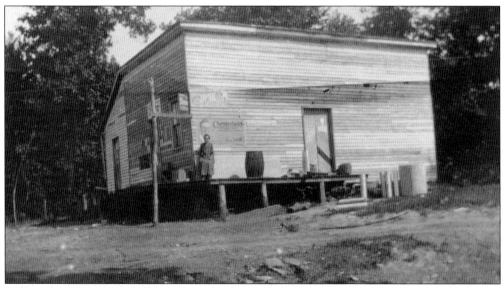

William Reed Moore built this store in the Green County community of Pikeview and operated it with his wife, Euna. Moore was previously involved in a business with his brother Thomas C. Moore in Gresham. As pay for groceries and other goods, Moore often accepted chickens, eggs, and grains; he would take the latter to a local mill for grinding. (PMJ.)

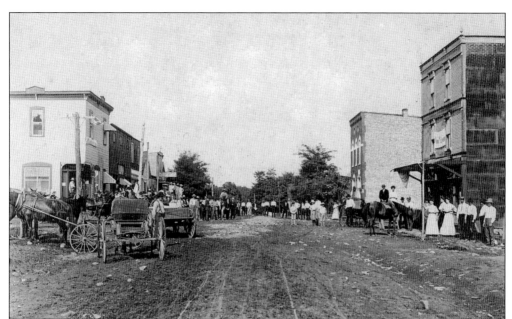

In 1817, Somersville was established by an act of the Kentucky Legislature and was laid out by John Emerson on the Lexington-Nashville road. The act appointed William T. Willis, Dr. James Howe, and William Philpot as the first trustees. By 1900, Summersville had stores, physicians, mills, and hopes for a college. Identifiable businesses in the 1906 photograph above include Lewis Franklin Risen's store (left); the Jacob Odewalt drugstore, begun in 1902 beyond Risen's; and the Farmer's Bank of Summersville, across the street. The bank boosted community hopes when it opened in the building pictured at right in September 1906. However, the Kentucky secretary of state, Ben L. Bruner, closed the bank in July 1911 for what the *Louisville Courier-Journal* reported as "too big loans." (Both, BW.)

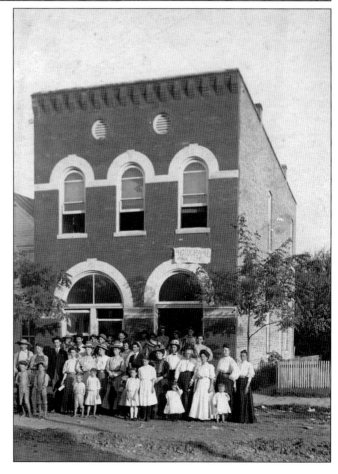

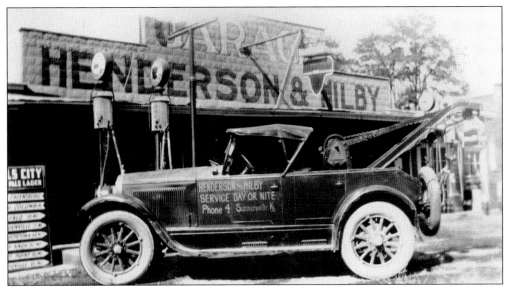

Brothers-in-law Jim Henderson and Garnett Milby operated a service station and grocery in Summersville for about 19 years. The garage featured Standard Oil products, and the grocery store sold lunches and cold drinks like Falls City beer, which is advertised on the sign at left. In 1939, the garage became the Pontiac dealer for Green County. Henderson bought out Milby in 1943 and continued operating the garage under the name Henderson's Garage and Grocery. (JHB.)

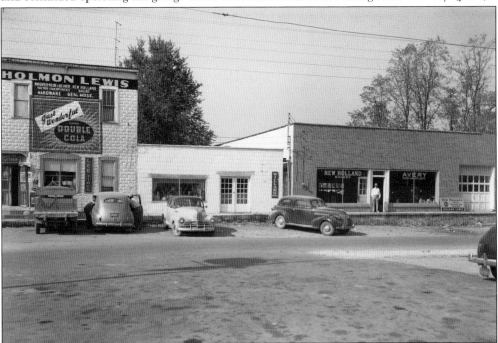

Holman Lewis ran a grocery store in Summersville in what had been Lewis Franklin Risen's store. Lewis's store had the first television set in Green County—Wilton McCubbin installed a Zenith set that received signals from the Louisville station. Lewis later became a dealer for New Holland farm equipment, and in December 1953, he became the Dodge dealer for Green County. (TCHS.)

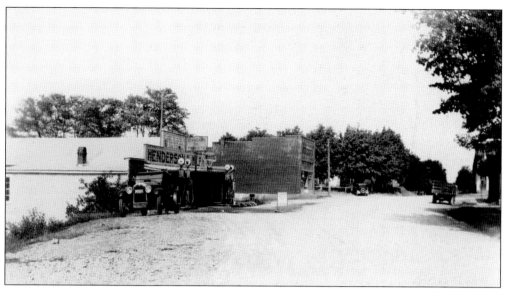

This view looks north on what is now Highway 61 toward the Summersville intersection with the former Lexington-Nashville turnpike (now the intersection of Pleasant Valley and Gabe Roads). The original entrance to Summersville's center was approximately 100 yards east. Many Summersville residents opposed the road change because it was moved from the existing town center. Henderson and Milby Garage is the first building on the left; next to it is Henry D. Mays's store. (JHB.)

George Durrett and Henry Williams owned this store in Gabe from about 1920 to 1940. The store carried groceries, dry goods, shoes, and kerosene. Lois Durrett Williams ran a millinery shop in part of the store. After George Durrett's death in 1938 and the aftermath of the Great Depression causing customers to have trouble paying their accounts (which, in turn, reduced the owners' ability to restock), the store was sold to Elmer Caven in 1940. (JYD.)

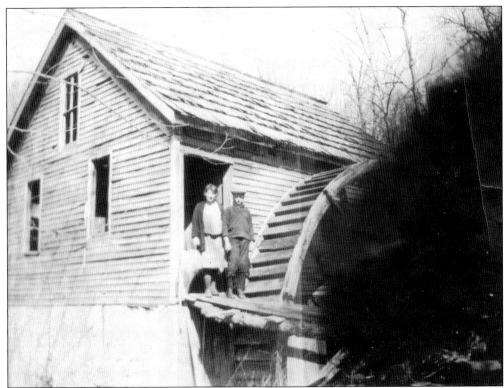

Ezekiel Young Jr. built the first mill in the Brush Creek section of Green County in 1816 and ran the mill with his nine daughters. After Young's death, his son-in-law John Bloyd ran the mill on what came to be known as Bloyd's Bluff. Most traces of the mill are gone, including the approximately-100-yard race that carried water from a large spring to the overshoot wheel. (BJB.)

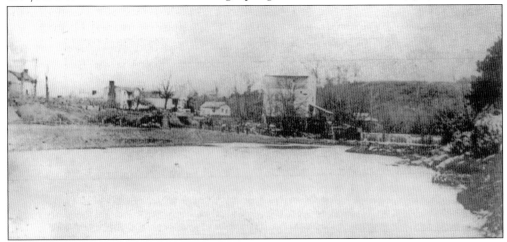

Osceola, incorporated in 1868, once stood on the Little Barren River near Hart County. Osceola thrived with a church, a school, numerous businesses and taverns, and a reputation—reported by Lanny Tucker—as a "wicked little river town." The latter may have motivated an 1874 act of the Kentucky Legislative that prohibited alcohol sales in Osceola or within two miles of the Osceola church. After being ravaged by several Little Barren River floods, residents abandoned the town. (LT.)

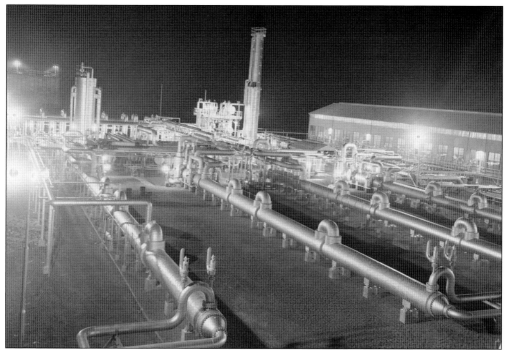

In May 1950, the Tennessee Gas and Transmission Company (TGT) of Houston opened a chemical stripping plant in Gabe. Built on 110 acres at an estimated cost of $12 million, the plant removed liquid hydrocarbons from the natural gas transported in the company's gas lines from Texas to the Appalachian states. The company sold the extracted liquid hydrocarbons to a plant being built in Meade County, Kentucky, as a joint effort between TGT and the Mathieson Chemical Company of Baltimore. Initially, the plant recovered approximately 400,000 gallons of liquid hydrocarbons daily from the six trillion cubic feet of natural gas passing through the pipeline. The facility also included on-site housing (below) for managers and employees. The plant ceased operations in the 1980s, and all vestiges of the production facility and the housing were removed. (TCHS.)

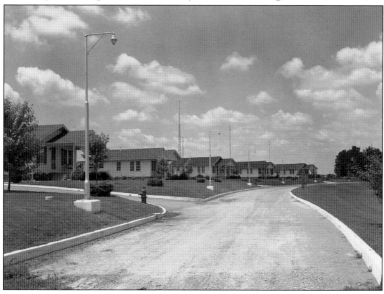

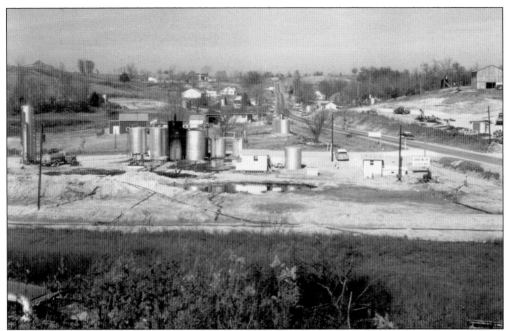

The community of Happyville, located north of Greensburg, was one of the earliest and most productive areas in the Green County oil boom of the 1950s and 1960s. In 1958, Leeco Oil Company, the largest leaseholder in the county, leased the 110-acre Happyville farm of Henry Caven, seen here, with plans to drill 12 wells on the site. By October of that year, oil from Green County's boom totaled one-third of Kentucky's entire oil production. (TCHS.)

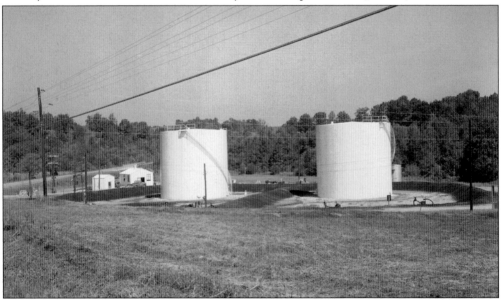

As the largest buyer of oil during the Green County boom of the 1950s and 1960s, Ashland Oil built two 10,000-barrel storage tanks on the Roy Milby farm north of Greensburg. About 80 trucks and 240 drivers made two or more round trips each day to the Ashland terminal in Louisville. In March 1959, Ashland completed a six-inch pipeline that directly carried oil 73 miles to the Louisville terminal. (TCHS.)

Four

GOVERNMENT

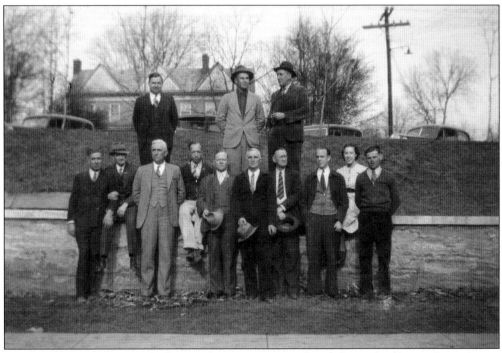

County officials posing outside the courthouse in 1938 are, from left to right, (first row) magistrates Albert Lee Rayburn and Kendree Thomas McMahan, county judge John Wilson Moore, tax commissioner Floyd Patterson, county attorney Vernon Shuffett, magistrate Alvin H. Landis, county clerk Olie Coffey, deputy county clerks Rhea Tucker and Naomi Coffey, and magistrate Frank Price; (second row) tax collector Howard Pickett, deputy sheriff George Dewitt, and sheriff Ezra Adkins. Dr. Archibald Lewis's house is visible in the background. (WL.)

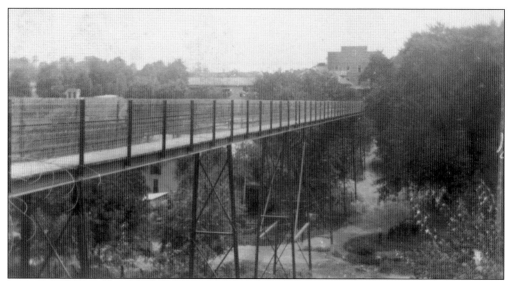

In November 1928, Greensburg voters approved a bond to fund a walking bridge from the public square to the depot. Prior to the bridge's completion in 1929, one had to walk up and down more than 100 steps on each side to cross the hollow between the square and the town's east side. The 450-foot bridge cost $4,500. The photograph also shows the three-story Workman building, which was completed in 1924, in the background. (ML.)

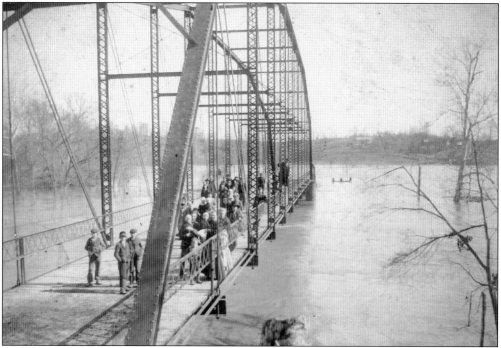

The Green River passes Greensburg on its way through Green County. For early settlers, the river provided a transportation route for tobacco and other products to get to New Orleans. However, before the completion of Green River Lake and Dam in 1969, the river's flooding also limited access between the north and south sides of the river for many Green County residents, as illustrated in this photograph taken during the record flood in January 1913. (JYD.)

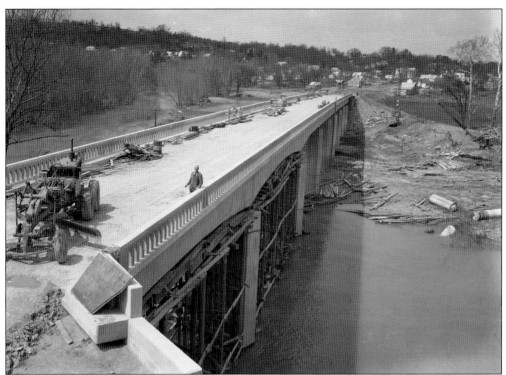

A two-span iron bridge crossed the Green River in Greensburg for almost 50 years until the state completed a new concrete bridge in 1951 despite severe winter weather and rains that had halted construction for weeks. Dedicated on June 5, 1951, in honor of Jane Todd Crawford, the 690-foot-long, 26-foot-wide bridge cost $362,000. During the building process, the state initially routed all traffic through Donansburg or Ebenezer. However, with funds from the state, the county, and local subscription, a shorter detour— known as the Burma Road—was built over Buckner's Hill. The man standing on the new bridge in the image above is Green County native Albert Lee Rayburn, a bridge and road inspector. Below, Kentucky governor Lawrence Weatherby joined in the dedication ceremony, where he was escorted by, from left to right, Jane Squires, Wanda Smith, Ruth Lewis, and Marilyn Higgason. (Above, TCHS; below, JYD.)

Lexington stonemason Waller Bullock completed the Green County Courthouse in 1804. It remains on the Greensburg public square today despite having been threatened by destruction in 1927 and altered dramatically in 1937 for use as a firehouse. After serving as a courthouse for almost 130 years, the building has since housed a school, a temporary location for the Greensburg Deposit Bank, and the Jane Todd Crawford Library. (GMH.)

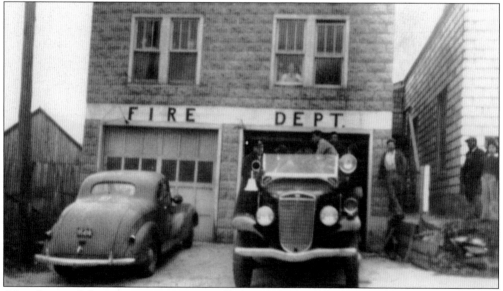

After the town's first water system was installed in 1937, Greensburg moved to acquire a fire truck and a firehouse. That same year, the city purchased its first fire truck, an International, from the Akin and Tucker dealership. The Howe Company of Ohio outfitted it with the necessary fire equipment. After ruling out using the old courthouse for a fire station, the city built this station on East Columbia Avenue. (SWM.)

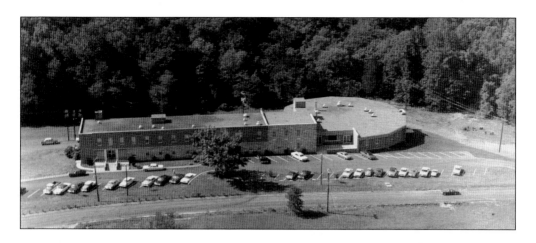

Discussions regarding a hospital for Green County began as early as 1923, and in 1951, county citizens voted for a $120,000 bond issue to support the hospital, but nothing developed. Discussions continued until 1959, when the federal government approved funds to purchase 10 acres of land on the former Hugh Howell farm for a hospital site. When it was finally completed in 1962 at a cost of $650,000, an estimated crowd of 2,500 people helped dedicate the 28-bed Jane Todd Crawford Memorial Hospital on October 2, 1962. Below, from left to right, Marjorie Parson Bloyd, Sylvia Hudson Collings, Louise Bishop Grey, and Faye Walters demonstrate equipment in the delivery room on dedication day. (Above, JYD; below, TCHS.)

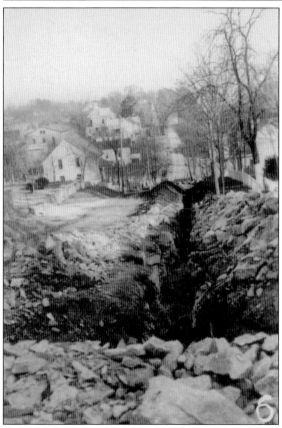

Construction began on the Greensburg water system in June 1934, after the Reconstruction Finance Corporation provided an initial $40,000 for work on the water system. Workmen finished laying pipes on the main streets in May 1936, followed by work on the filtration plant, the reservoir, and the sewer system. The project initially employed workers under the Civil Works Administration, a temporary jobs program started by Pres. Franklin D. Roosevelt. With additional money from the Works Progress Administration, the city hired approximately 91 workers to complete the sewer project, and water flowed to Greensburg users in 1937. Above, workers dig a ditch in the first alley east of Main Street. The image at left shows a ditch in progress on West Columbia Avenue looking east. (Above, WL; left, UK.)

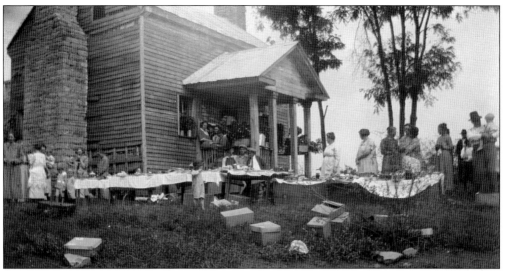

The Green County poorhouse, pictured here in the 1930s, is first mentioned in the 1826 county records. Individuals and families unable to sustain themselves might be provided for at the poorhouse, though the county also provided through the county levy. Occasionally, the Kentucky Legislature approved legislation requiring the county to maintain individuals without sending them to the poorhouse. (NCM.)

Until 1952, only Columbia Avenue provided access between Main Street in Greensburg and the town's east side, creating traffic congestion during the tobacco season, basketball tournaments, and other school functions. In the November 1951 election, Greensburg voters approved a bond issue to finance the extension of Hodgenville Avenue eastward from Greensburg Baptist Church on Main Street. The extension, which opened in July 1952, improved traffic flow. (TCHS.)

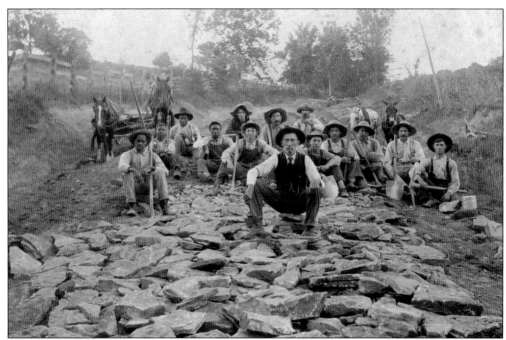

Until the 1900s, responsibility for road building in Green County rested with the county and the residents. Whenever roadwork was required, the fiscal court assigned an area resident to superintend the work, and all males age 16 and above were conscripted to assist. Each man brought his own tools, and the county paid for the wagons and teams used in the work. (BW.)

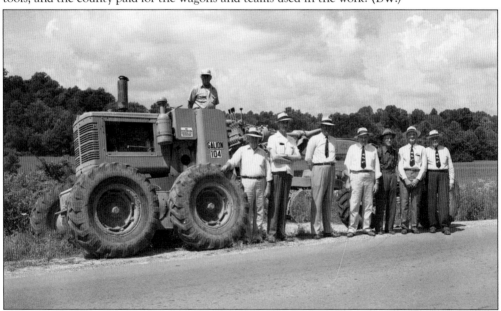

Green County officials show off a new Galion Model 104 grader purchased in July 1953 from Brandeis Machinery and Supply Company of Louisville. Edwin Blaydes is atop the grader. County officials standing in front of the grader include, from left to right, county court clerk Carl Wade, county attorney L. Victor Henderson, magistrate Thomas J. Gorin Jr., county judge Boyce Hudson, magistrate Luther Davis, magistrate Howard T. Hodges, and magistrate Ray Clark. (TCHS.)

With the support of local civic leaders, Green County received its first library bookmobile (above) in September 1954. The bookmobile represented a significant outreach for the Jane Todd Crawford Memorial Library, which had its beginnings in 1933 in the old Green County Courthouse. In 1938, the Works Progress Administration stocked the library on the second floor of the old courthouse with 500 books. It was called the Pack Horse Library because it sent workers into the county on horses or on foot with books and magazines for those unable to make the journey to the library. With the help of the Greensburg Woman's Club, the library moved to the main floor of the courthouse in November 1941. A revitalized library (below) reopened in the old courthouse in 1958 with 4,000 books. (Above, GCLIB; below, TCHS.)

First the Federal Emergency Relief Association and then the Works Progress Administration initiated a number of sewing circles led by Mary Durham, a Green County social worker. The circles, which began in 1934, served as both a work-giving measure and a dispensary for clothes, bedding, and other necessary items for the poor. In 1941, the Greensburg circle moved to the Llewellyn M. Henderson building, in front of which they posed for this picture. (JYD.)

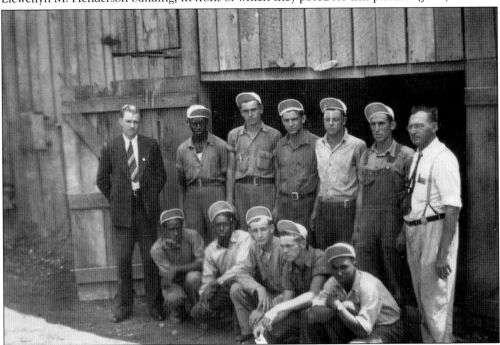

When Fred Kreke moved to Greensburg in 1931, he established a cabinet shop to make furniture and restore antiques. In this 1937 photograph, Kreke is at right in the white shirt with boys from the National Youth Administration (NYA), who were employed to make furniture during the Depression. In 1937, a total of 49 NYA boys were doing various jobs in Green County, including making furniture, doing roadwork, and cleaning Greensburg's streets and alleys. (WL.)

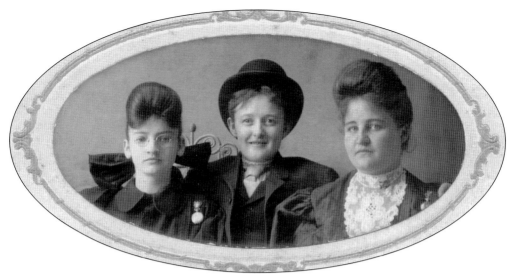

Judith Wakefield Montgomery (center) served as postmistress at the Greensburg post office from May 1914 until July 1924, during which time it moved from a fourth-class to a third-class office. Only two women have served as Greensburg postmistresses since the post office began in 1807—Montgomery and Exie Dowdy. Judith is pictured above with her cousin, Mary Montgomery (left), and her friend, Bertha Breeding (right). (JHH.)

In April 1956, the Greensburg post office was moved from the Durham building to the adjacent building to the east, the Llewellyn M. Henderson building (pictured). The new location provided twice the space, and the post office remained in this location until 1962, when it moved to its current location on South Main Street. Greensburg's city hall now occupies this building. (TCHS.)

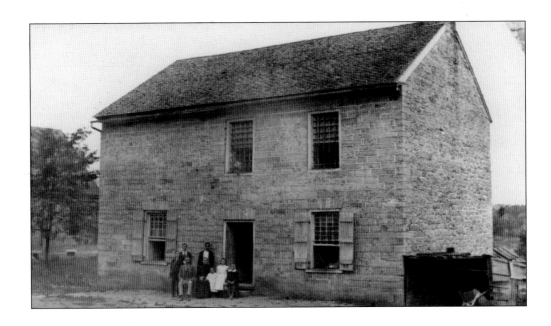

In 1830, the Green County Court purchased Greensburg lot number 128 for use as a site for a new jail, then contracted with Henry Sanders to build the jail. In 1902, the county drilled a well to provide water for the jail. Green County jailer Isaac Shadrack "Dick" Coffey (seated at left) is pictured above with his family in front of the jail. In March 1931, two prisoners set the jail on fire by punching a hole in the ceiling, stuffing paper in the cracks, and setting the paper alight with matches they found in their cell. After the jail was destroyed, the Green County Fiscal Court (the renamed Green County Court) built a courthouse on the lot in 1933. (Above, SWM; below, JYD.)

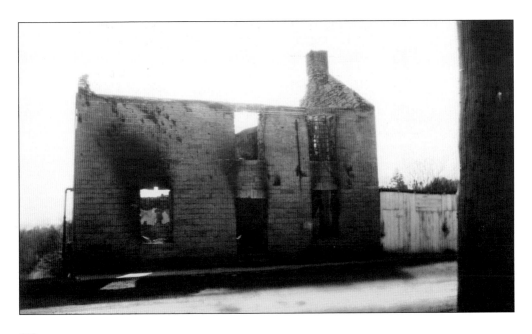

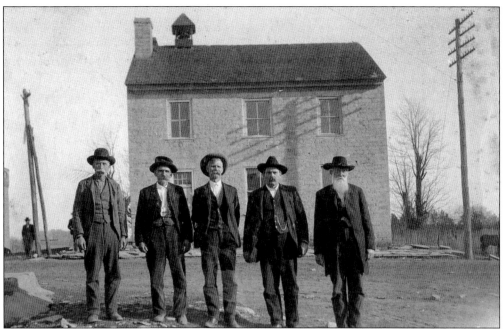

The image above shows the Green County Board of Tax Assessors, which included, from left to right, Daniel Walton Woodward, A.D. Bridgewater, Alfred Pierce, Edd Blakeman, and Billie Underwood. The sheriff is noticeably absent. When the Cumberland & Ohio Railroad failed to complete its line through the county, residents resented paying taxes to retire the $100,000 bond. Consequently, if the county elected a sheriff, he could not make the bond without collecting the railroad tax, which was a nearly impossible task. As a result, no one officially served as sheriff from 1879 to 1921. Below, county officials gathered for a photograph in the early 1900s. They are, from left to right, tax collector Edward Elias Perkins, judge William Green Howell, tax collector Larkin McGinnis, judge Elliott Graham, tax collector Bill Jones, magistrate Ed Lewis Chaudoin, magistrate Rufus Burress, magistrate Showdy Rhea, Vernon Coffey, magistrate George Durrett, county clerk Perry Marshall, and jailer Dick Coffey. (Above, NM; below, SWM.)

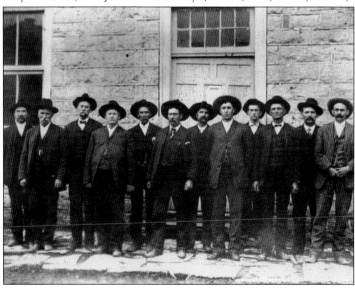

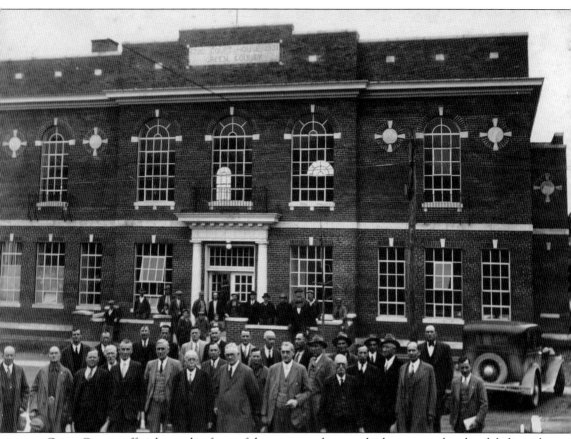

Green County officials stand in front of the new courthouse, which was completed and dedicated in 1933. The three-story structure included court and jury rooms on the third floor, county offices on the second floor, and a jail and the jailer's residence on the first floor. Louisville architect Edwin W. Archer provided plans for the building. This building and its location resulted from an official effort to tear down the stone courthouse on the public square and replace it with a courthouse in the square's center. In one of Kentucky's earliest preservation lawsuits, local citizens formed a committee and sued the county to stop the demolition of the 1804 courthouse. After the judge ruled in favor of the citizens' committee, the county elected to build on the site of the former county jail, which had been damaged in a 1931 fire. (SWM.)

Five

PERSONS

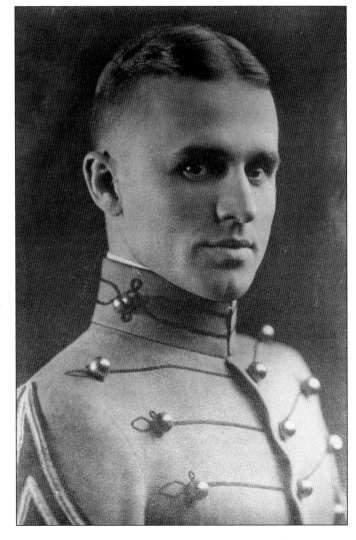

The first Green County native to graduate from West Point, Woodson Lewis was the grandson of William Lewis, who began one of the longest-lasting businesses in Greensburg. Woodson enlisted in World War I as a private in 1917. He spent two years in service and was then selected to attend West Point. When his brother William died in 1927, Woodson resigned from the service in order to run the family mercantile business, which was then known as the Woodson Lewis Store. (RLD.)

Reuben W. Creel, a member of a well-known mercantile family from Green County and the surrounding area, served as deputy clerk to John Barret in 1841 and as a soldier in the Mexican War. He spent the rest of his life in Mexico. Creel's son, Philippe, returned to the United States as an ambassador from Mexico. (JM.)

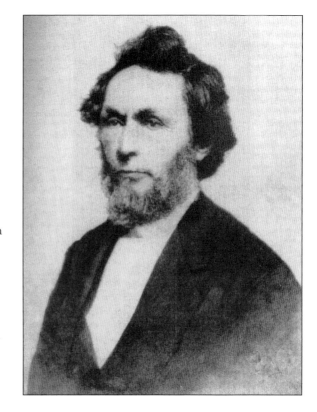

Born on December 28, 1818, in Greensburg, William Henry Herndon became Abraham Lincoln's law partner in Illinois. Upon Lincoln's death, Herndon began extensive research with a goal of writing Lincoln's biography. It was not until the 1880s, when he joined with DePauw University graduate Jesse W. Weik, that Herndon completed *Herndon's Lincoln: The True Story of a Great Life*, which was published in 1889. (RP.)

Mentor Graham, who was born in the Brush Creek area of Green County, taught school in Green County before moving to Sangamon County, Illinois, in 1826. In 1833, he taught the only school in New Salem, Illinois, where he was Abraham Lincoln's teacher for about six months. Graham died in Blunt, South Dakota, in 1886. (RP.)

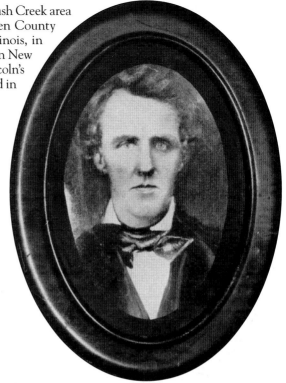

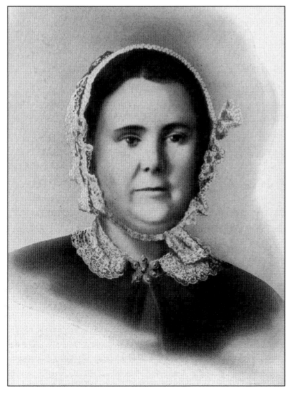

Mary Owens was the daughter of Nathaniel Owens, a wealthy Green County landowner and the county's first sheriff. Mary eventually married Jesse Vineyard and moved to Missouri, where she died. She gained some historical recognition as the result of visits to her sister, Betsy Abell, in New Salem, Illinois. There, she met Abraham Lincoln, and they shared a brief courtship. The future president made an awkward marriage proposal, which she refused. (RP.)

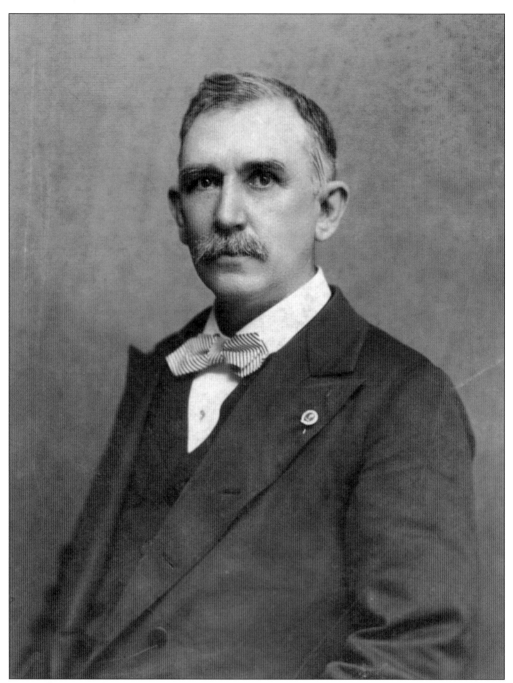

Dr. William P. White, who was born in Greensburg on April 21, 1845, attended Georgetown College until the Civil War began. He left school, joined the Confederate army in Arkansas, and served until the war ended. He then returned to school, completed his degree, and entered the University of Louisville Medical School, from which he graduated. He served as the chief medical officer for the City of Louisville before being appointed Kentucky's surgeon general by Gov. Preston Leslie. Dr. White was the son of Dr. Daniel Price White Sr., a Green County native and a member of the Confederate Congress. (JYD.)

George Washington Buckner, born into slavery in 1855 in Green County, earned an education and taught briefly in Green County before moving to Indiana and graduating from Indiana State Normal School. He spent several years teaching in Vincennes, Washington, and Evansville before receiving a degree as a doctor from the Indiana Eclectic Medical College in Indianapolis. His first wife died in 1889, and he remarried in 1896 after moving to Evansville and opening a medical practice. In 1913, Pres. Woodrow Wilson appointed Buckner as the minister and consul general to Liberia, a post he held until 1915. Frequent illness brought on by a fever caught in the tropical climate forced him to resign and return to Evansville, where he died in 1943. (EMAHS.)

Virginia native Jane Todd Crawford moved to Green County with her husband, Thomas Crawford, in 1805. In 1809, she rode horseback from Green County to Danville, Kentucky, where Dr. Ephraim McDowell operated on Crawford to remove an ovarian tumor that weighed 22 pounds in the first ovariotomy performed in the United States. The 25-minute surgery was completed without anesthetic. Jane Todd Crawford died in Indiana in 1842. (JYD.)

James Luke Creel, born in Green County, graduated from Greensburg High School in 1924. Before he graduated from the University of Illinois in 1934, Creel won the university prize for creative writing three times. He taught at Buena Vista College in Storm Lake, Iowa, and at Gustavus Adolphus College in St. Peter, Minnesota. In addition to poetry, he published *Folk Tales of Liberia*, a work based on folk tales from the Via tribe of Liberia. (MN.)

Greensburg native Gen. Edward Henry Hobson was instrumental in bringing the Cumberland & Ohio Railroad to Greensburg and served on that company's board. A veteran of the Mexican War, he fought for the Union in the Civil War, becoming a brigadier general after the Battle of Shiloh. In 1863, his command captured Confederate general John Hunt Morgan, but Morgan escaped. After the Civil War, Hobson became quite active in business and civic affairs. (SWM.)

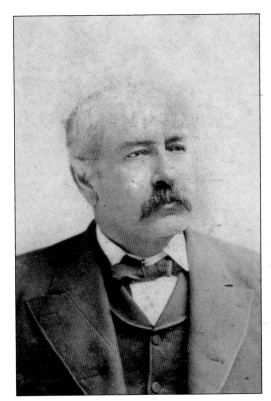

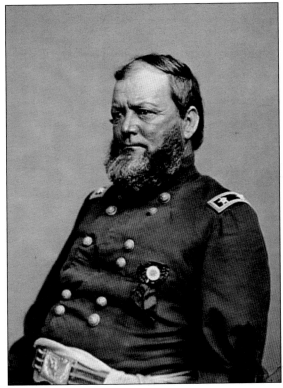

Gen. William Thomas Ward, a Mexican War veteran and a US Congressman (he served from 1851 to 1853), was born in Greensburg in 1808. He was commissioned a Union brigadier general in 1861 after raising a brigade. He was part of the Atlanta campaign and Sherman's March to the Sea through the Carolinas. He was severely wounded in Resaca, Georgia, in 1864 and was mustered out in 1865 as a major general. (SW.)

Rev. Dr. William Harvey Woods Jr., the son of Rev. William Harvey Woods and Sarah Catherine Lile, was born in Greensburg on November 17, 1852. He graduated from Hampden-Sydney College and Union Theological Seminary. Woods became nationally known as a poet, publishing poems in *Scribner's Magazine*, *Century Magazine*, and numerous other publications. He spent the last 30 years of his ministerial service at Franklin Square Presbyterian Church in Baltimore, Maryland. (JYD.)

William Barret Allen was born to Capt. David Allen and Martha Todd Barret in Greensburg on May 19, 1803. Allen had a variety of occupations, including newspaper editor, attorney, postmaster, cashier of the Bank of Kentucky branch in Greensburg, and Green County representative to the Kentucky Legislature. He is best known locally for his book, *History of Kentucky*, which contains important information about early Green County. (JBM.)

Six
RELIGION

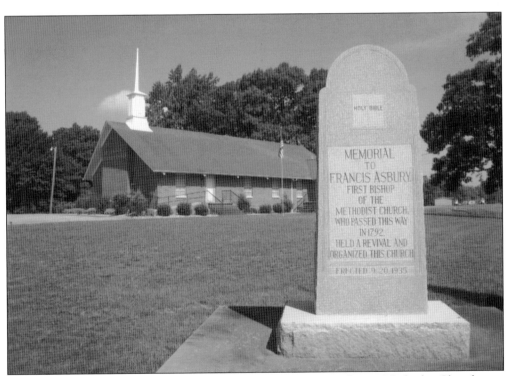

In 1935, Methodists erected this monument adjacent to the Mt. Lebanon Methodist Church near Thurlow. Methodist bishop Francis Asbury held a revival in Green County and organized the Mt. Lebanon Church when he passed through the county in 1792. The monument was initially planned for the site where Asbury preached, but a failure to obtain the landowner's approval caused the monument to be moved to the churchyard. (JYD.)

In 1890, John Garret Barret, a Green County native and prominent Louisville businessman, built Greensburg Presbyterian Church in memory of his parents, John and Mary Barret. The rusticated stone building replaced a brick structure that had fallen into disrepair, or—based on some recent archeological discoveries—perhaps burned. Unfortunately, Barret died before the building was completed. (JYD.)

Barret was born in Greensburg in 1829. After graduating from the University of Louisville Law School, he joined in a law practice with Nathaniel Wolf. He turned to banking in 1862, when he became cashier of the Southern Bank of Kentucky. He was later cashier and president of Citizens Union Bank and president of National Stock Yards (later named Bourbon Stock Yards). (JYD.)

Oral tradition identifies this building, which formerly sat on the east side of present-day Depot Street, as the Siloam Meeting House. The building served multiple congregations. Joseph Akin, a local businessman and the son-in-law of well-known Presbyterian David Rice, sold the lot to the trustees of the Siloam Meeting House in 1824. Three years later, the Siloam Meeting House trustees resold the lot and the building, which was in use as a cotton factory at the time of the sale. (TCHS.)

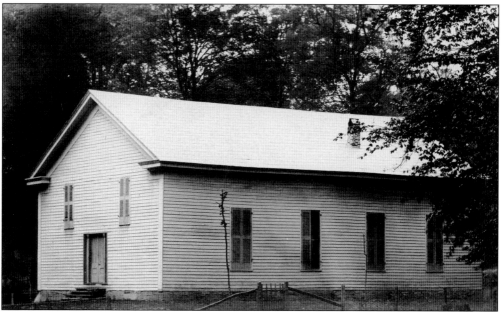

One of the first ministers at Ebenezer Presbyterian Church, which was constituted in October 1799, was Rev. David Rice, known as the "Father of Presbyterianism" in Kentucky. Reverend Rice had purchased land and moved to Green County in 1798. Despite Rice's initial help in starting Ebenezer Presbyterian, the church struggled throughout the 1800s with organizational issues and inconsistent pastoral leadership; today, however, the church is thriving. (SWM.)

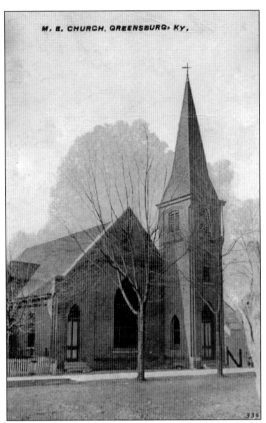

M. E. CHURCH, GREENSBURG, KY,

The Greensburg Methodist Church congregation dedicated its church building (left) in June 1895. In 1912, they wired the church for electric lights, and in 1916, they built a choir loft. In 1938, efforts began to erect a new structure. After securing sufficient pledges, the church contracted to have the old building demolished and a new one constructed on the site. During the process, the Methodists held services in the newly constructed courthouse just across the street. J.F. Pace Company of Burkesville constructed the new building (below) at a cost of $30,000. The church held a dedication ceremony in May 1939. In 1940, the church donated the weather vane from the old church to the city, and it was placed atop the bell tower of the old courthouse. The 1939 Methodist church building remains in use today. (Both, TDM.)

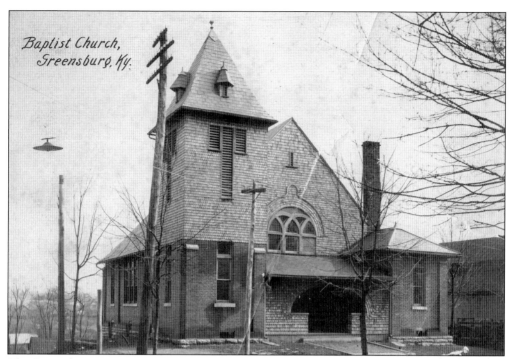

The Greensburg Baptist Church, pictured above, was built between November 1895 and August 1901. The building replaced a smaller brick church that included a 20-foot bell tower. Baptists purchased the lot in July 1841 from James Bradshaw, who had purchased the lot in 1802 from Hugh Montgomery, its first owner. In April 1945, a runaway truck loaded with grain and fertilizer hit the brick tower and vestibule, severely damaging the building; the congregation soon began to plan for a new structure. The building at far right was a livery and feed stable constructed sometime between 1901 and 1908. (JHH.)

Greensburg Baptist Church completed a new educational wing (right rear) in 1948, holding services there after it was completed, and dedicated the building in 1952. Construction on the new auditorium began in April 1954, and the first service was held in the sanctuary in March 1956. (TCHS.)

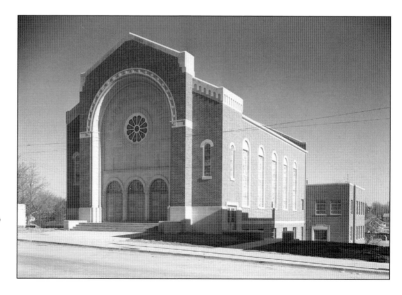

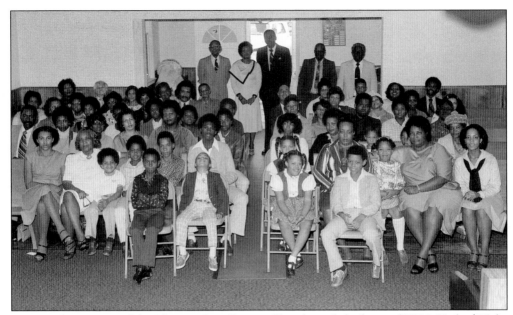

In 1871, the trustees of the Pleasant Run Baptist Church paid the heirs of W.M. Hicks $25 for land on the Campbellsville pike "near rock run church." Pleasant Run was the home church of Alex Robinson, a master mason who completed work on many of Greensburg's buildings. This photograph shows the interior of Pleasant Run Baptist Church. (TCHS.)

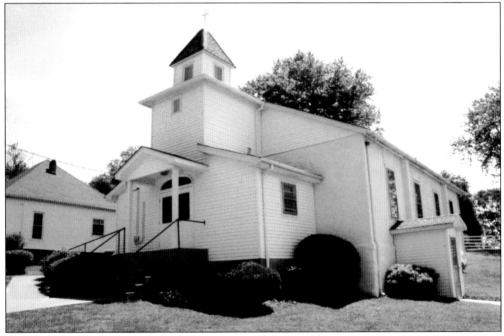

In 1870, the First Baptist Colored Church trustees acquired a building and land on present-day South First Street, where they had already established a church and school. In 1913, the church—now called the Greensburg Colored Baptist Church—acquired two acres of land on which to construct a new church building just east of the colored school in Greensburg's Shreve addition. The church dedicated the new building (pictured) on that site in 1919. (JYD.)

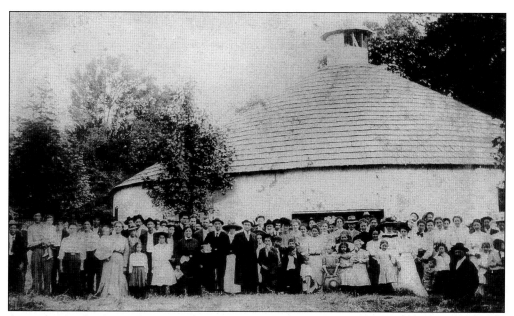

Around 1904, the Green County Holiness Association began a summer camp meeting at Glenview. The association built this large meeting structure, a hotel with a dining room, a livery stable, and rental cottages. People from Green and its surrounding counties attended the annual religious meetings, which lasted for about 10 days. None of the campground buildings still exist. (DJ.)

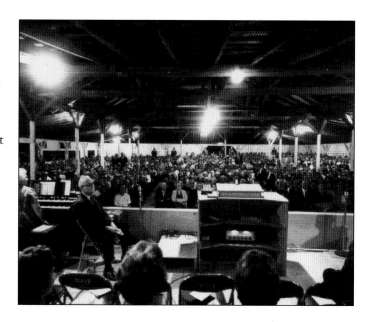

Clay Milby (seated at front left), awaits the beginning of the September 1962 Green County Evangelistic Crusade. A total of 2,000 people packed the Nazarene Tabernacle and an auxiliary tent for the last meeting. A Green County native, Milby dedicated his life to leading the singing at revivals and crusades. The tabernacle was part of a campground started in 1944 by the Summersville Nazarene Church that included men's and women's dormitories and a dining room. (TCHS.)

The Greensburg Cumberland Presbyterian Church began as the result of a 1912 tent revival in Greensburg. Members from the Campground Cumberland Presbyterian Church joined with Greensburg members, creating a congregation of about 60. Dr. James Booker, who lived in a house adjacent to the site, donated the land for the church. Work began on the building in 1916, and the church held its first service in April 1918. (TCHS.)

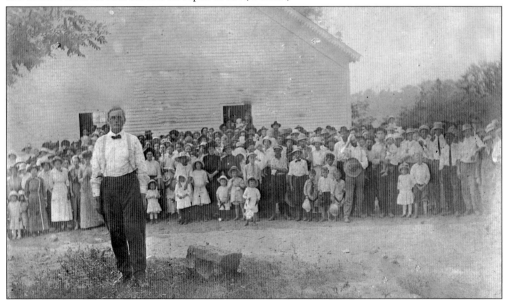

Rev. Joseph Furkin stands in front of his Oak Forest Cumberland Presbyterian Church congregation in Gabe. Reverend Furkin served Green and the adjoining county churches for about 40 years. Records indicate that Rev. Thomas Marshall organized the Oak Forest church in February 1854. However, a Cumberland Presbyterian congregation existed as early as 1844, as the heirs of James Calhoon sold one acre and a "new meeting house" for use by the congregation. (JYD.)

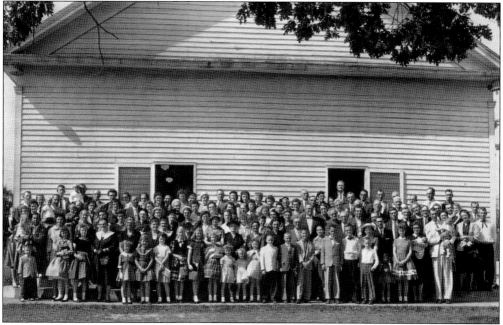

Established around 1800, Trammel Creek Church belonged to the Green River Association of Baptist Churches. In 1804, the Green River Association divided into three associations, and Trammel Creek became a charter member of the Russell Creek Association. The first church was built of logs and sat on the north side of the Liletown road. The frame building above was built across the road around 1885. (JSW.)

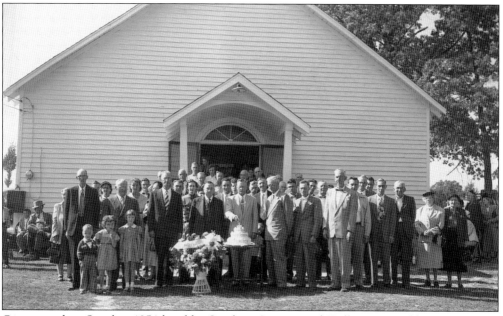

Constituted in October 1854 by elder Stephen Gupton and William M. Kidd, Greasy Creek Baptist Church celebrated its 100th year in October 1954. The church's first building was a log church that was torn down in 1943 and replaced by this building at a cost of $1,552.98. In 1960, the church moved to a new building east of this one. (TCHS.)

Initially known as Mt. Gilead Meeting House, this church began around 1800 as a Baptist church. It sits on the site where the Long Hunters made camp around 1770, building a small house to store furs, but had to leave the building behind because of Indian raids. When they returned a few years later, they found all of their work ruined. (JYD.)

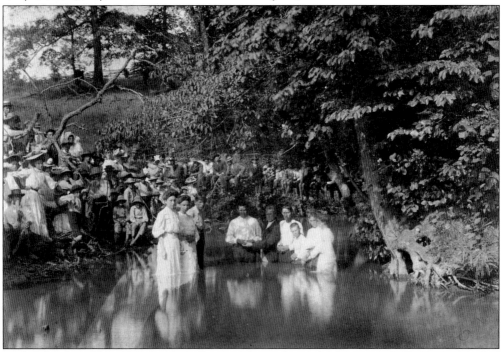

In the absence of baptisteries inside the churches—due to high costs or lack of space—rural churches used local streams for baptismal services. This photograph captures an unknown minister conducting a baptism near Pleasant Valley Baptist Church, probably in Little Brush Creek, which flows nearby. (BW.)

Seven

SPORTS

Coach Carl Deaton (third row, second from left) coached the Green County High School basketball team to its only trip to the state basketball tournament when the GCHS Dragons beat Caverna 61-60 in the 1976 Fifth Region tournament. In 2003, Coach Deaton was named to the Dawahares/Kentucky High School Athletic Association Hall of Fame. His son, Mike (first row, third from right), later played quarterback for the University of Kentucky. (MD.)

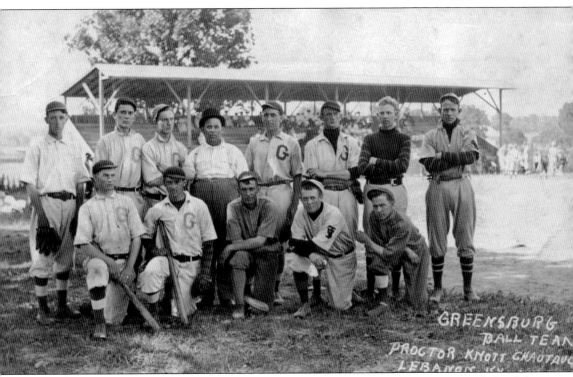

This 1911 baseball team includes, from left to right, (first row) Willie Gumm, Will Sandidge, Taylor Cox, Wood Vaughn, and Ben Lewis; (second row) Ezra Gumm, Richard Hagan, Roe Shreve, manager James W. Durham, Will Moore, Berley Young, unidentified, and Romie Judd. Before the present-day Legion Park was built, teams played at Henry Park, which was located somewhere near the area of Henry Street, and at Howell Park, just south of town off Highway 61. (JYD.)

Larry "Pee Wee" Gumm remains the most successful high school baseball coach in Kentucky. Upon his retirement in 2007, Gumm had won 1,006 games, making him the first of his kind in the state to win 1,000 games. He was twice a finalist for national baseball coach of the year and has been inducted into the Kentucky High School Baseball Coaches Association Hall of Fame and the National High School Athletic Coaches Association Hall of Fame. (TCHS.)

Finis Wilson was the first Green County native to become a professional baseball player. He played with Cleveland, New Orleans, and the Brooklyn Federals before returning to Greensburg. After his wife died in 1921, he remained in Greensburg until 1926, during which time he served in the Kentucky Legislature and worked at the Green River Milling Company. He moved to Memphis in 1929 and became a federal alcohol agent. (BP.)

Donations and pledges provided sufficient money to build the pool pictured below at the American Legion Park in 1959. It was 75 feet long, 25 feet wide at the deep end, and 45 feet wide at the shallow end, with high and low diving boards. The Gun-Crete Company of Louisville completed work on the pool in time for its June 1959 opening. (TCHS.)

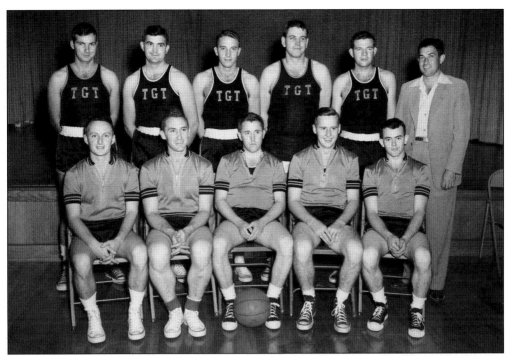

Green County has also fielded amateur teams, such as this 1953 Tennessee Gas and Transmission (TGT) Gabe plant employee basketball team, which included, from left to right, (first row) Holland "Sonny" Pickett Jr., Donald Salsbury, Eulice "Coonie" Raschel, Ed Whitley, and Gene Money; (second row) Claude "Punkin" Sharp, Johnny Broome, Doug Jones, Boyer Jones, Brooks Edwards, and coach V. Cathy Moss. The team played exhibition games with the "B" teams of schools like Lindsey Wilson College and barnstorming teams such as the Red Heads, a traveling women's basketball team. Another opponent of theirs was the Whiskered Wizards (below), a team composed of former All-American college and ex-service stars. Located in St. Augustine, Florida, the Wizards were managed by Bill Steinecke, a former catcher who played part of one season with the Pittsburgh Pirates. The Wizards arrived to play the TGT team on November 18, 1953, carrying a seven-season record of 851 wins and 98 losses. (Both, TCHS.)

The 1929–1930 Greensburg High School girls' basketball team (above) included, from left to right, (first row) Elsie Coakley, Elizabeth Cox, Grace Wilcoxson, Eva Tucker, and Opal Burress; (second row) Eleanor Graham, Lorainne Pickett, Jane Anderson, and Helen Clark; (third row) teacher Evelyn Cannon Wade and coach Elizabeth Pitman. The boys' team (below) included, from left to right, Bill Trusty, Jack Twyman, George McKenzie, Bob McMahan, Ollie Montgomery, William Cox, Boyce Marcum, Clay Mitchell, Russell Phillips, and coach Raymond Peterson. According to the *Greensburg Record-Herald*, both teams wanted "to achieve the well-nigh impossible task of beating Columbia High School," something not accomplished throughout the season. Columbia visited Greensburg in February 1930, and the boys won a "nip and tuck affair from start to finish." In a "wild-fire finish," the girls "trounced the visitors 9 to 1." (Above, JYD; below, GMH.)

BIBLIOGRAPHY

Allen, William B. *A History of Kentucky*. Reprint. Green County Historical Society, Greensburg, KY: 1967.

Boatner, Mark M. III. *The Civil War Dictionary*. Rev. Ed. New York: Vintage Books, 1991.

Carruthers, Olive and R. Gerald McMurtry. *Lincoln's Other Mary: The Courtship of Mary Owens*. New York: Ziff-Davis Publishing Co., 1946.

Duncan, Kunigunde and D.F. Nickols. *Mentor Graham: The Man Who Taught Lincoln*. Chicago: University of Chicago Press, 1944.

Evans, Kate Powell. *A History of Green County, Kentucky 1793–1993*. Lexington, KY: American Printing Co., 1993.

Green County Record.

Greensburg Record-Herald.

Jeffries, Clevis. *Greensburg High School Basketball . . . From Beginning to End*. Greensburg, KY: Quad Printing, 2011.

Kleber, John E., ed. *The Kentucky Encyclopedia*. Lexington, KY: University of Kentucky Press, 1992.

Lebanon Weekly Standard.

Lebanon Weekly Standard & Times.

Perrin, W.H., J.H. Battle, and G.C. Kniffin. *Kentucky: A History of the State*, Fourth Edition Reprint. Easley, SC: Southern Historical Press, 1979.

Tucker, Lanny. *History Among Us*. Columbia, KY: South Central Printing Co., 2007.

DISCOVER THOUSANDS OF LOCAL HISTORY BOOKS
FEATURING MILLIONS OF VINTAGE IMAGES

Arcadia Publishing, the leading local history publisher in the United States, is committed to making history accessible and meaningful through publishing books that celebrate and preserve the heritage of America's people and places.

Find more books like this at
www.arcadiapublishing.com

Search for your hometown history, your old stomping grounds, and even your favorite sports team.